PUBLISHER NOTES:

Catalog-In-Publication Data has been applief for and may be obtained from the Library of Congress.

ISBN: 978-1-947215-15-3

US Copyright: TX0008935990

Book Design and Cover Design by Joseph Stevenson

Printed and bound in the U.S.A.

Golden Valley Press books are available at special discounts when purchased in quantity for premiums and promotions as well as fundrasing or educational use. Special editions can also be created to specification. All requests should be submitted through our website www.josephstevenson.com

Golden Valley Press
PO Box 531412
Henderson, NV 89052

SECTION 1: EYES

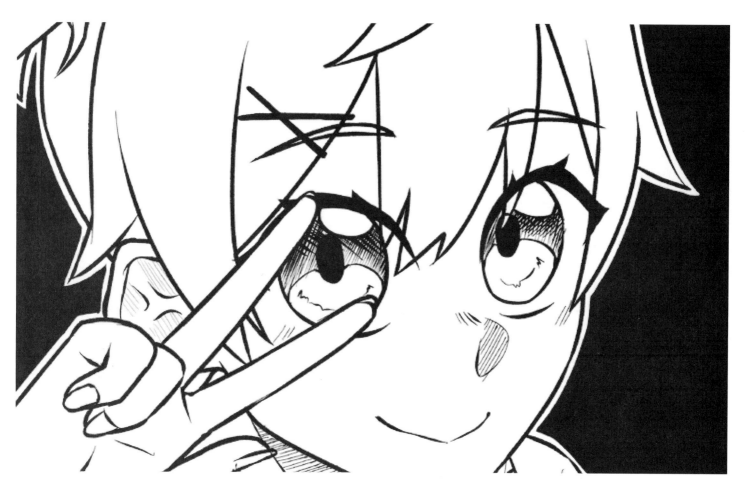

INTRODUCTION

EYES ARE EASILY ONE OF THE MOST EXPRESSIVE PARTS OF A CHARACTER IN ANIME AND MANGA, AND CAN ALLOW THE VIEWER TO GET AN IDEA OF THE PERSON BEFORE THEY EVEN SEE THEM MOVE! THERE ARE TROPES AND STYLES THAT HAVE A KNOWN STYLE FOR THEIR EYES, BUT EVEN THEN THIS ISN'T A CONCRETE THING.

THE WAY EYES ARE DRAWN CAN MAKE A CHARACTER LOOK COMPLETELY DIFFERENT FROM DRAWING TO DRAWING AS WELL, JUST BY CHANGING THE DETAILS OR SHAPES OF THE EYES.

THE AMOUNT OF EXPRESSIONS AND HUGE VARIETY OF STYLES CAN MAKE THIS A BIT OF A DAUNTING TASK TO OVERCOME, BUT AS LONG AS YOU UNDERSTAND THE BASICS AND BREAK THEM DOWN STEP BY STEP, YOU WILL BE LEARNING AND CREATING YOUR OWN TYPE OF EYES IN NO TIME!

FOR THIS SECTION WE WILL BE GOING THROUGH A STEP-BY-STEP PROCESS WITH THREE DIFFERENT ARTISTIC STYLES:
- SIMPLE
- DETAILED
- CHIBI

TO START OFF YOUR JOURNEY INTO THE WORLD OF DRAWING MANGA AND ANIME INSPIRED DRAWINGS.

LET'S GET STARTED!

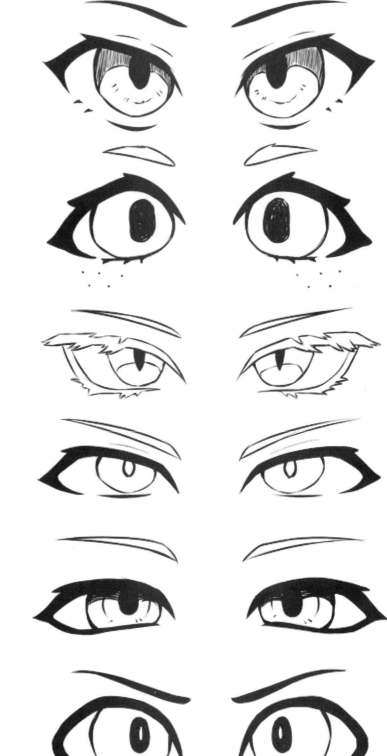

TYPES OF EYES

THESE ARE THE TYPES OF STYLES WE WILL BE GOING OVER IN THIS BOOK:

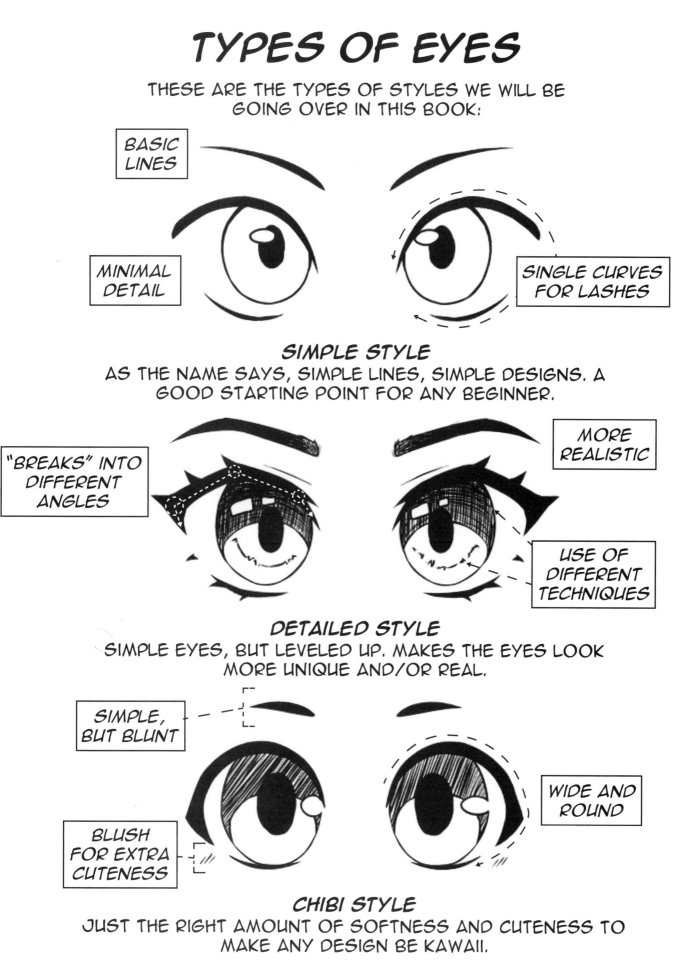

BASIC LINES

MINIMAL DETAIL

SINGLE CURVES FOR LASHES

SIMPLE STYLE
AS THE NAME SAYS, SIMPLE LINES, SIMPLE DESIGNS. A GOOD STARTING POINT FOR ANY BEGINNER.

"BREAKS" INTO DIFFERENT ANGLES

MORE REALISTIC

USE OF DIFFERENT TECHNIQUES

DETAILED STYLE
SIMPLE EYES, BUT LEVELED UP. MAKES THE EYES LOOK MORE UNIQUE AND/OR REAL.

SIMPLE, BUT BLUNT

BLUSH FOR EXTRA CUTENESS

WIDE AND ROUND

CHIBI STYLE
JUST THE RIGHT AMOUNT OF SOFTNESS AND CUTENESS TO MAKE ANY DESIGN BE KAWAII.

SIMPLE EYES

THE BASIC SHAPES AND SIMPLE LINES ARE AN EASY WAY TO GET THE HANG OF DRAWING EYES AS A BEGINNER. IT IS ALWAYS A GOOD THING TO START WITH THE BASICS BEFORE ADDING MORE DETAILS, THAT WAY YOU CAN BUILD A SOLID FOUNDATION FOR YOUR DRAWING JOURNEY.

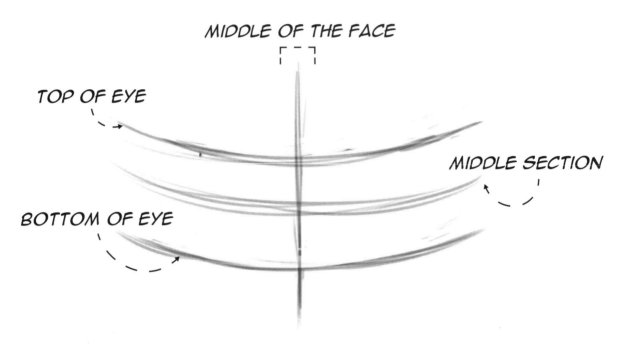

MIDDLE OF THE FACE

TOP OF EYE

MIDDLE SECTION

BOTTOM OF EYE

CREATE GUIDELINES SO YOU KNOW WHERE KEY POINTS OF THE EYES WILL GO. DOING THIS CAN HELP WITH MAKING SURE THAT THE EYES WILL LAY ON THE FACE CORRECTLY, ESPECIALLY WHEN DRAWING THEM FROM AN ANGLE (BUT WE WILL TALK ABOUT THAT LATER ON IN THE BOOK).

ANN'S ART TIP:
DRAWING THE SAME SECTIONS OF THE EYES AT THE SAME TIME WILL HELP KEEP THEM EVEN AND SYMMETRICAL!

4

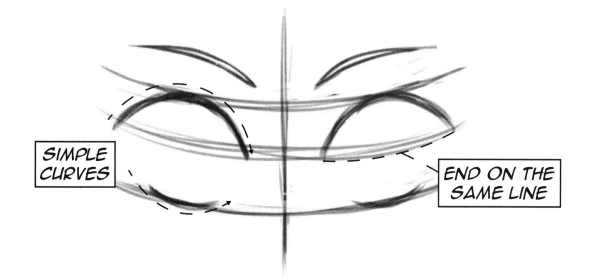

SIMPLE CURVES

END ON THE SAME LINE

START OFF WITH THE "EYELASHES" A.K.A. THE OUTER EDGES OF THE EYES, AS WELL AS THE EYEBROWS. SINCE THESE ARE SIMPLE EYES, WE WILL GO WILL GENERIC CURVES.

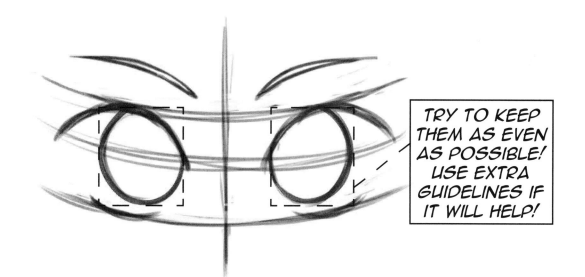

TRY TO KEEP THEM AS EVEN AS POSSIBLE! USE EXTRA GUIDELINES IF IT WILL HELP!

ONCE YOU ARE DONE WITH THAT, SKETCH TWO OVAL-LIKE SHAPES TO CREATE THE IRIS.

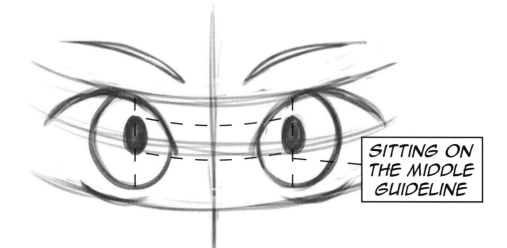

SITTING ON
THE MIDDLE
GUIDELINE

AFTER THE IRIS IS MADE, WE WILL MAKE TWO SMALLER
CIRCLES IN THE IRIS, WHICH WILL BE OUR PUPILS.
REMEMBER TO NOT DRAW THEM TOO FAR APART!

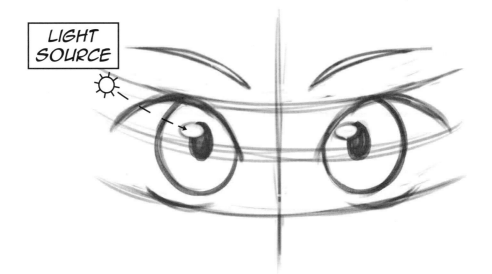

LIGHT
SOURCE

IF THERE IS A SOURCE OF LIGHT, DON'T FORGET TO
ADD IT SO THE EYES CAN HAVE A BIT OF SHINE TO THEM.
WHERE EVER THE LIGHT IS COMING FROM IS WHERE THE
SHINY PART SHOULD BE!

ITS NOT ONLY IMPORTANT TO READ THE STEPS, BUT TO TRY THEM OUT AS WELL! PLEASE USE THIS EMPTY SPACE TO PRACTICE THE STEPS YOU HAVE READ ON THE PREVIOUS PAGES.

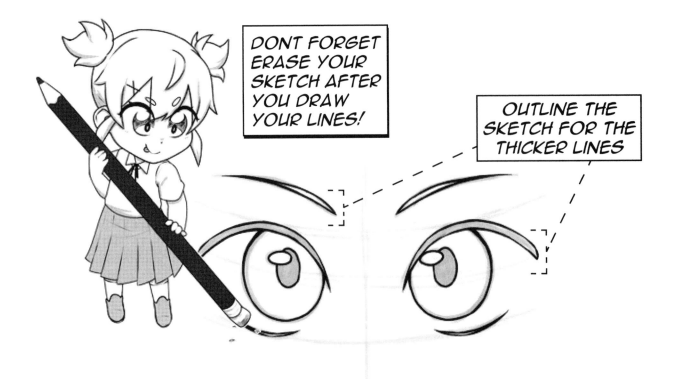

DONT FORGET ERASE YOUR SKETCH AFTER YOU DRAW YOUR LINES!

OUTLINE THE SKETCH FOR THE THICKER LINES

ONCE THE SKETCH IS FINISHED, IT IS TIME TO DO DRAW THE DARKER LINES ABOVE THE SKETCH. THIS IS THE MOST EFFECTIVE WHEN USING INK OVER A LIGHT PENCIL SKETCH.

OUTLINING YOUR THICK LINES BEFORE FILLING THEM ALLOWS YOU TO ERASE YOUR PENCIL SKETCH, MAKING THE FINISHED LINES LOOK CLEANER!

REMEMBER TO LET THE INK DRY BEFORE ERASING THE SKETCH!

8

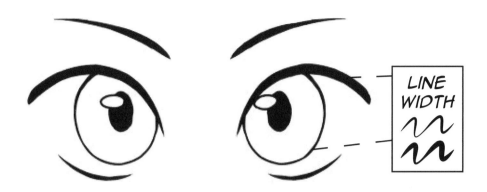

DEPENDING ON HOW THICK THE EYES ARE, IT MIGHT REQUIRE MORE OR LESS INK TO FILL IN THE LASHES AND PUPILS.

ONCE YOU ARE DONE FILLING IN THE EMPTY SPACE, YOU CAN NOW SAY YOU COMPLETED A PAIR OF SIMPLE EYES! THIS IS A GOOD STARTING POINT FOR QUICK AND EFFECTIVE EYES, BUT IF YOU WANT TO ADD A BIT OF FLAIR OR UNIQUENESS TO YOUR EYES, THEN YOU SHOULD LOOK AT HOW TO ADD SOME NICE DETAILS.

IME'S ART TIP:
DRAWING WITH DIFFERENT TYPES OF LINE THICKNESSES CAN MAKE IT LOOK MORE PROFESSIONAL AND DYNAMIC!

9

ITS NOT ONLY IMPORTANT TO READ THE STEPS, BUT TO TRY THEM OUT AS WELL! PLEASE USE THIS EMPTY SPACE TO PRACTICE THE STEPS YOU HAVE READ ON THE PREVIOUS PAGES.

DETAILED EYES

DETAILED EYES ARE GREAT BECAUSE THEY CAN BE BASED OFF OF A SIMPLE PAIR OF EYES, BUT WHAT SETS THEM APART IS THE FACT THAT IT IS MORE COMPLICATED AND TIME CONSUMING.

WHILE THAT MAY SOUND DAUNTING, THIS IS GREAT FOR WHEN YOU REALLY WANT YOUR CHARACTERS TO HAVE DIFFERENT APPEARANCES, AND TO ALSO AVOID SAME FACE SYNDROME*. (NOTE: THIS ISN'T ALWAYS BAD, BUT ITS IMPORTANT TO LEARN VARIETY FIRST!)

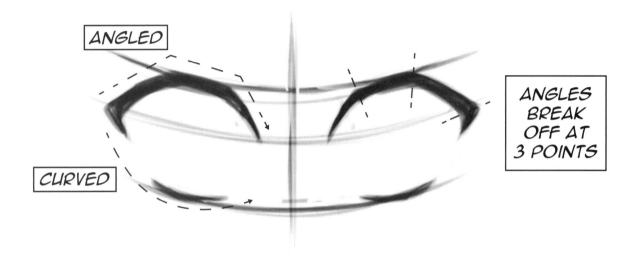

SIMILAR TO THE SIMPLE EYES, CREATE GUIDELINES TO KEEP YOUR EYE SHAPES EVEN AND ON THE FACE CORRECTLY. THE TYPE OF LINES WE WILL BE USING IS MORE DYNAMIC THAN BEFORE, BEING A COMBINATION OF CURVED AND STRAIGHT LINES.

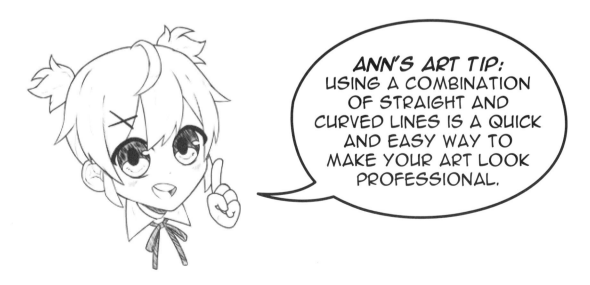

*SAME-FACE SYNDROME:
WHEN EVERY CHARACTER HAS THE SAME FACIAL APPEARANCE.

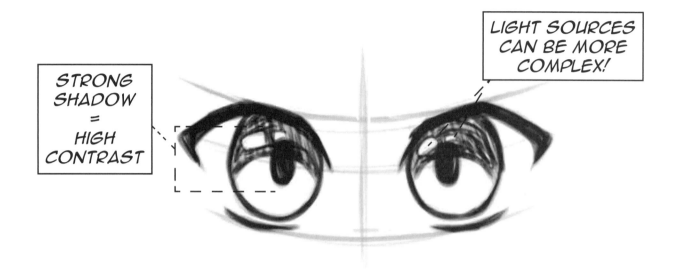

STRONG SHADOW = HIGH CONTRAST

LIGHT SOURCES CAN BE MORE COMPLEX!

FOLLOW THE SAME STEPS FROM THE SIMPLE EYES, ADDING YOUR IRIS, PUPILS AND SHINE, BUT NOW WE WILL BE ADDING A SHADOW. IT ADDS DIMENSION TO THE EYES AND HELPS MAKE THE SHINE STAND OUT.

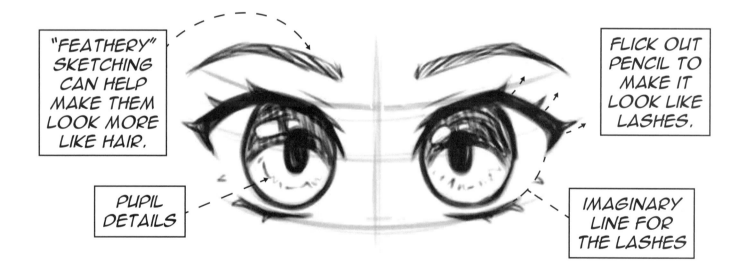

"FEATHERY" SKETCHING CAN HELP MAKE THEM LOOK MORE LIKE HAIR.

FLICK OUT PENCIL TO MAKE IT LOOK LIKE LASHES.

PUPIL DETAILS

IMAGINARY LINE FOR THE LASHES

AFTER YOU GET THE BASICS FINISHED, IT IS TIME TO ADD SOME DETAILS, LIKE EYELASHES OR SPARKLES IN THE EYES (THIS PART IS UP TO YOU, BUT FOR THESE WE WILL GO WITH SOME LASHES, AND MARKS IN THE EYES). OUR EYEBROWS ARE NOW MORE DETAILED AS WELL, SHOWING SOME OF THE HAIRS IN THE BROW.

ITS NOT ONLY IMPORTANT TO READ THE STEPS, BUT TO TRY THEM OUT AS WELL! PLEASE USE THIS EMPTY SPACE TO PRACTICE THE STEPS YOU HAVE READ ON THE PREVIOUS PAGES.

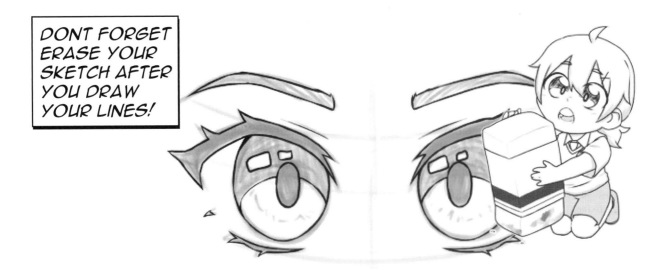

DONT FORGET ERASE YOUR SKETCH AFTER YOU DRAW YOUR LINES!

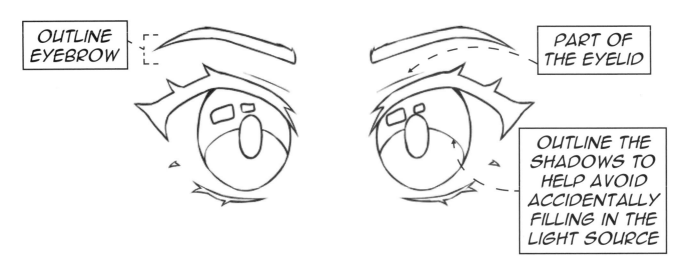

OUTLINE EYEBROW

PART OF THE EYELID

OUTLINE THE SHADOWS TO HELP AVOID ACCIDENTALLY FILLING IN THE LIGHT SOURCE

WHEN YOUR SKETCH IS DONE, WE CAN NOW MOVE ON TO THE LINE ART. THIS IS WHEN VARYING LINES CAN REALLY HELP GIVE YOUR EYES A UNIQUE LOOK!

FILL IN LASHES CAREFULLY TO AVOID MAKING THE LINES TOO THICK

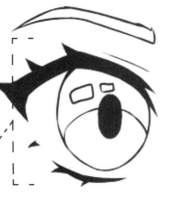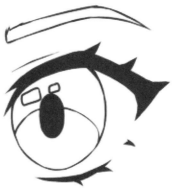

NOW IT IS TIME TO FILL IN THE GAPS OF THE LINES. FOLLOW THE SAME STEP FROM THE SIMPLE EYES, BUT ONLY DO IT FOR THE IRIS AND LASHES.

14

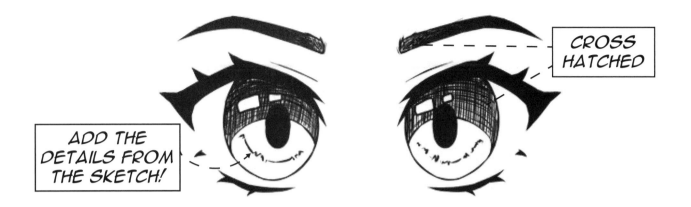

CROSS
HATCHED

ADD THE
DETAILS FROM
THE SKETCH!

THIS IS WHEN DETAILS LIKE **HATCHING** AND **CROSS-HATCHING**
CAN HELP ADD MORE DEPTH TO THE EYES. SO WE WILL BE USING
THOSE TECHNIQUES FOR THE SHADOWS AND EYEBROWS. THE
AMOUNT OF DETAILS YOU CHOOSE TO ADD OR OMIT IS UP TO YOU!

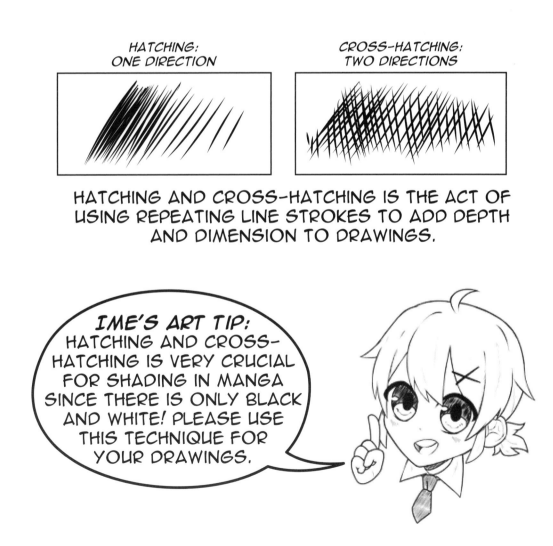

HATCHING:
ONE DIRECTION

CROSS-HATCHING:
TWO DIRECTIONS

HATCHING AND CROSS-HATCHING IS THE ACT OF
USING REPEATING LINE STROKES TO ADD DEPTH
AND DIMENSION TO DRAWINGS.

IME'S ART TIP:
HATCHING AND CROSS-
HATCHING IS VERY CRUCIAL
FOR SHADING IN MANGA
SINCE THERE IS ONLY BLACK
AND WHITE! PLEASE USE
THIS TECHNIQUE FOR
YOUR DRAWINGS.

ITS NOT ONLY IMPORTANT TO READ THE STEPS, BUT TO TRY THEM OUT AS WELL! PLEASE USE THIS EMPTY SPACE TO PRACTICE THE STEPS YOU HAVE READ ON THE PREVIOUS PAGES.

USUALLY ROUNDER AND "SOFTER" IN APPEARANCE, THE BASE FOR CHIBIS ARE MOSTLY DIFFERENT DUE IN PART THAT THEY ON A DIFFERENT BODY PROPORTION. THEY CAN HAVE A LOT OF VARIETY AS WELL, BUT LET'S LOOK AT SOME GENERIC KEY TRAITS THAT MAKE UP A PAIR OF CHIBI EYES AND FOLLOW THESE STEPS.

DEPENDING ON THE STYLE OF CHIBI, SOME ARTISTS WILL OMIT REALISTIC REFERENCES FOR CUTESY DETAILS. WE WILL BE FOCUSING ON A BASIC AND COMMON DESIGN.

REMEMBER TO PUT ONE VERTICAL GUIDE LINE GOING DOWN THE FACE, THEN ONE HORIZONTAL AND SLIGHTLY CURVED LINE TO GUIDE THE EYES ACROSS THE FACE.

SIMPLE GUIDELINES ARE USED BECAUSE CHIBI EYES ARE LESS REALISTIC THAN THE OTHER TYPES.

FIRST, LAY OUT A GUIDELINE FOR THE EYES. FOR CHIBI EYES, THESE GUIDELINES CAN BE SIMPLER, SINCE THE ANATOMY IS THE LEAST REALISTIC OUT OF ALL THREE DESIGNS.

CHIBI EYES ARE NOTORIOUS FOR THEIR ROUND AND CUTE APPEARANCE, SO WHEN YOU ARE DRAWING CHIBI EYES, IT IS BEST TO AVOID A SHARP GAZE. THERE ISN'T ANY RULES SAYING YOU CAN'T DO THAT, BUT THE GOAL OF CHIBI DESIGNS IS TO COMPACT A CHARACTER DOWN INTO A CUTE AND SMALL FORM.

THE EYELASHES FOR A CHIBI STYLE TEND TO ANGLE DOWNWARD, CREATING A PUPPY-EYE LOOK, ADDING TO THE CUTENESS FACTOR.

THE BOTTOM GUIDE LINE IS A GOOD POINT TO PUT THE LASHES NEAR.

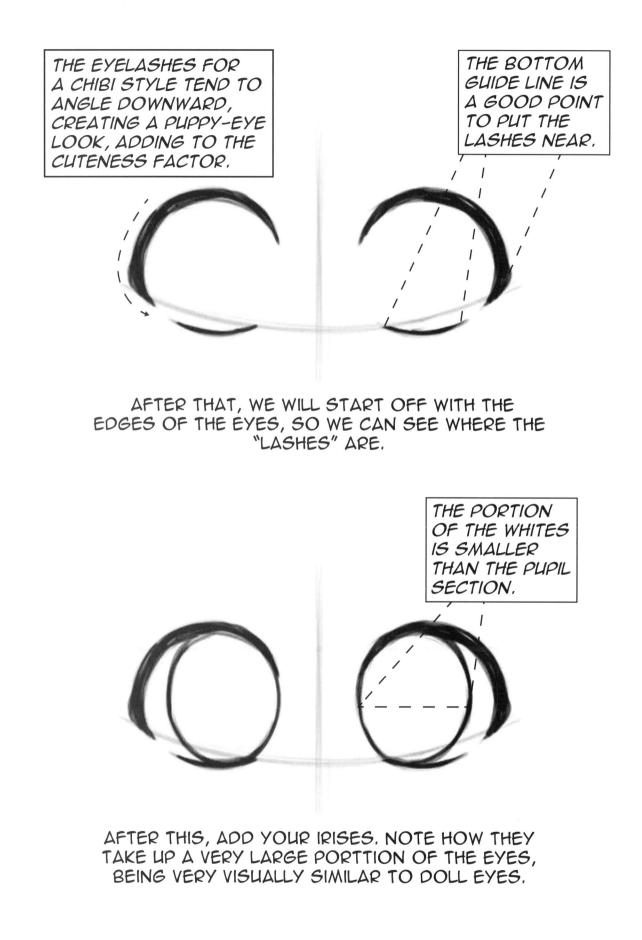

AFTER THAT, WE WILL START OFF WITH THE EDGES OF THE EYES, SO WE CAN SEE WHERE THE "LASHES" ARE.

THE PORTION OF THE WHITES IS SMALLER THAN THE PUPIL SECTION.

AFTER THIS, ADD YOUR IRISES. NOTE HOW THEY TAKE UP A VERY LARGE PORTTION OF THE EYES, BEING VERY VISUALLY SIMILAR TO DOLL EYES.

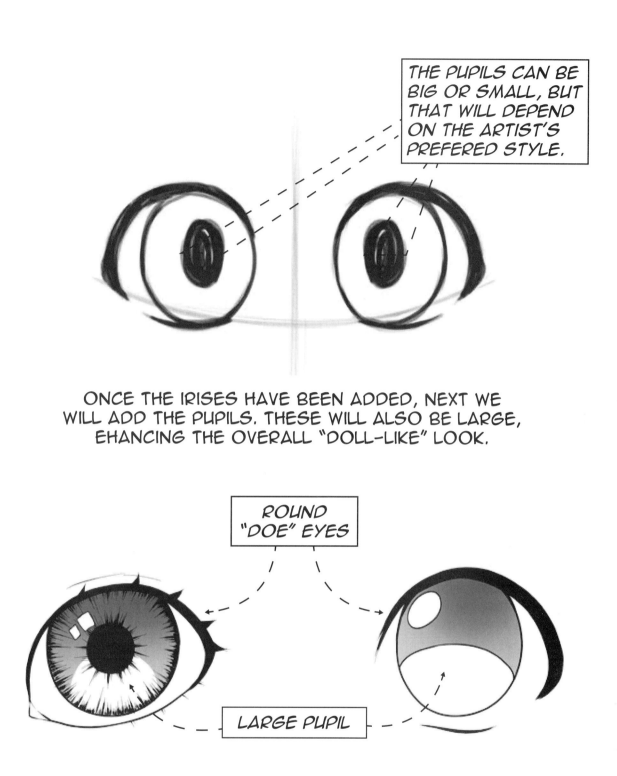

THE PUPILS CAN BE BIG OR SMALL, BUT THAT WILL DEPEND ON THE ARTIST'S PREFERED STYLE.

ONCE THE IRISES HAVE BEEN ADDED, NEXT WE WILL ADD THE PUPILS. THESE WILL ALSO BE LARGE, EHANCING THE OVERALL "DOLL-LIKE" LOOK.

ROUND "DOE" EYES

LARGE PUPIL

IF YOU LOOK AT THE SAMPLE, YOU CAN SEE WHERE THE SIMILARITIES BETWEEN DOLL EYES AND THE CHIBI STYLE.

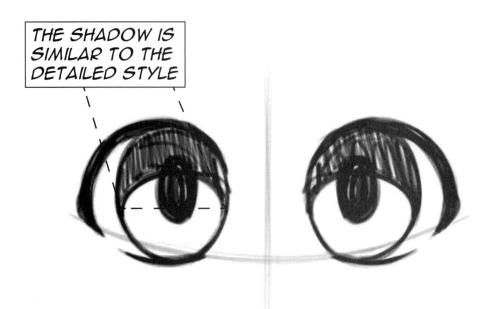

NEXT THING UP IS THE SHADOWS. NOTICE HOW THE SHADOWS TAKE UP A THIRD OF THE EYES? THIS IS TO HELP FURTHER EXAGERATE A DOLL EYE LOOK.

THE EYEBROWS, WHEN ADDED, WILL BE SIMPLER AND VISIBLY SMALLER IN COMPARISON TO THE OTHER STYLES.

PLEASE REMEMBER THAT WHERE EVER THE SOURCE OF LIGHT IS, THAT IS WHERE THE SHINE SHOULD BE!

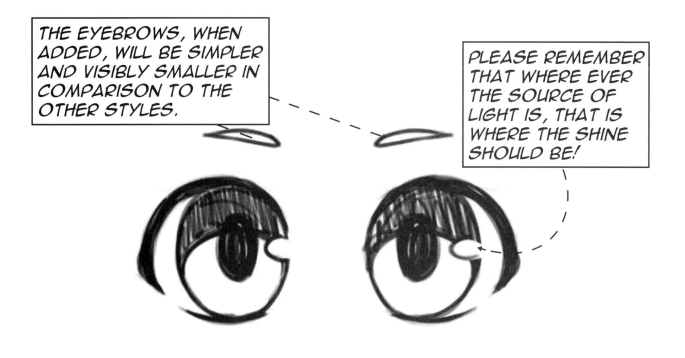

CHIBI EYES CAN BE REALLY SHINY (TO FURTHER ADD TO THEIR CUTENESS) SO GO AHEAD AND ADD THAT SPARKLE TO THEM.

ITS NOT ONLY IMPORTANT TO READ THE STEPS, BUT TO TRY THEM OUT AS WELL! PLEASE USE THIS EMPTY SPACE TO PRACTICE THE STEPS YOU HAVE READ ON THE PREVIOUS PAGES.

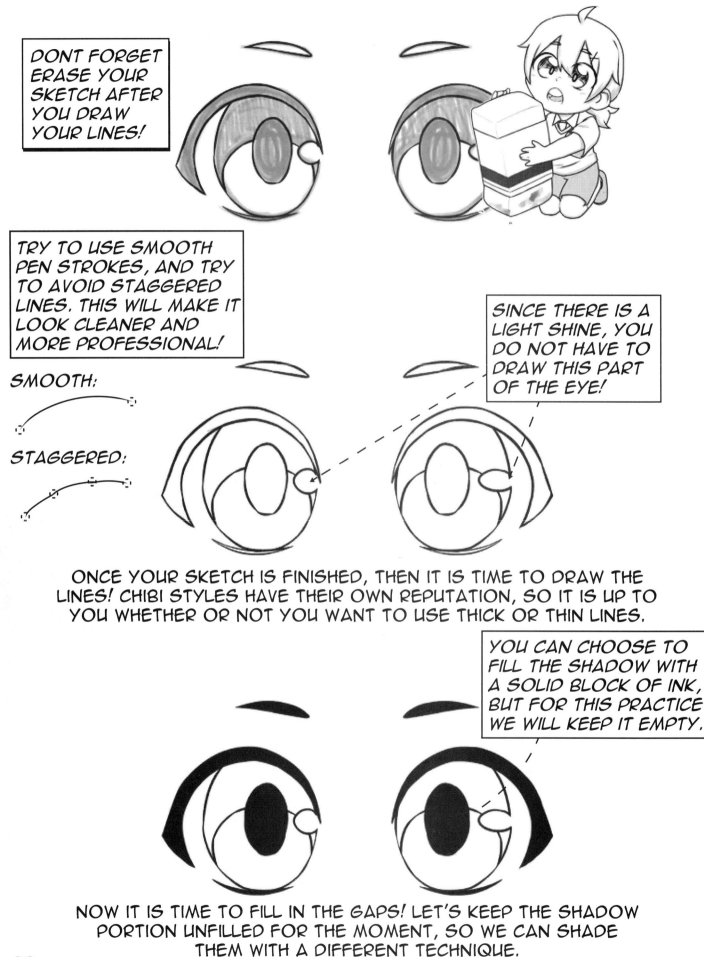

DONT FORGET ERASE YOUR SKETCH AFTER YOU DRAW YOUR LINES!

TRY TO USE SMOOTH PEN STROKES, AND TRY TO AVOID STAGGERED LINES. THIS WILL MAKE IT LOOK CLEANER AND MORE PROFESSIONAL!

SMOOTH:

STAGGERED:

SINCE THERE IS A LIGHT SHINE, YOU DO NOT HAVE TO DRAW THIS PART OF THE EYE!

ONCE YOUR SKETCH IS FINISHED, THEN IT IS TIME TO DRAW THE LINES! CHIBI STYLES HAVE THEIR OWN REPUTATION, SO IT IS UP TO YOU WHETHER OR NOT YOU WANT TO USE THICK OR THIN LINES.

YOU CAN CHOOSE TO FILL THE SHADOW WITH A SOLID BLOCK OF INK, BUT FOR THIS PRACTICE WE WILL KEEP IT EMPTY.

NOW IT IS TIME TO FILL IN THE GAPS! LET'S KEEP THE SHADOW PORTION UNFILLED FOR THE MOMENT, SO WE CAN SHADE THEM WITH A DIFFERENT TECHNIQUE.

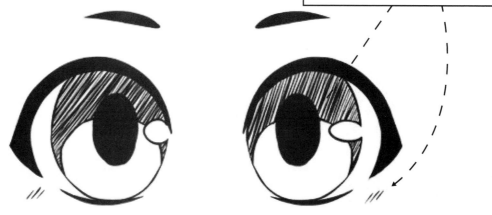

HATCHING IS GOOD FOR SIMPLE DESIGNS, AS WELL AS ADDING A SOFT BLUSH EFFECT TO THE SKIN.

LET'S USE HATCHING FOR A SIMPLE BUT EFFECTIVE WAY SHADE THE SHADOW PORTION OF THE EYES. FOR SOME ADDED CUTENESS, LETS USE SOME LIGHT HATCHING TO MAKE BLUSH AT THE BOTTOM CORNER OF THE EYES

ONCE YOU HAVE FINISHED THIS LAST STEP, YOU CAN SAY THAT YOU HAVE DRAWN A PAIR OF CUTE CHIBI EYES! HOORAY! NOW YOU MAY BE WONDERING, "WHAT IF MY CHARACTER IS MORE RUGGED AND SERIOUS THEN CUTE?" HAVE NO FEAR, BECAUSE REMEMBER THAT CHIBI EYES HAVE MANY VARIATIONS, JUST LIKE THE OTHER STYLES.

IME'S ART TIP: TRY WORKING OUT DIFFERENT STYLES, OR LOOKING AT HOW DIFFERENT ARTIST'S HAVE TACKLED THIS TASK. RESEARCH IS AN ARTIST'S BEST FRIEND!

23

ITS NOT ONLY IMPORTANT TO READ THE STEPS, BUT TO TRY THEM OUT AS WELL! PLEASE USE THIS EMPTY SPACE TO PRACTICE THE STEPS YOU HAVE READ ON THE PREVIOUS PAGES.

ANGLES

NOW THAT YOU HAVE A BASIC UNDERSTANDING OF THESE DIFFERENT TYPE OF EYES, WE CAN LOOK AT DIFFERENT ANGLES AND HOW TO DRAW THEM. FEEL FREE TO USE ANY VERSION YOU WANT (EVEN YOUR OWN DESIGNS IF YOU FEEL COMFORTABLE!) FOR THIS PRACTICE.

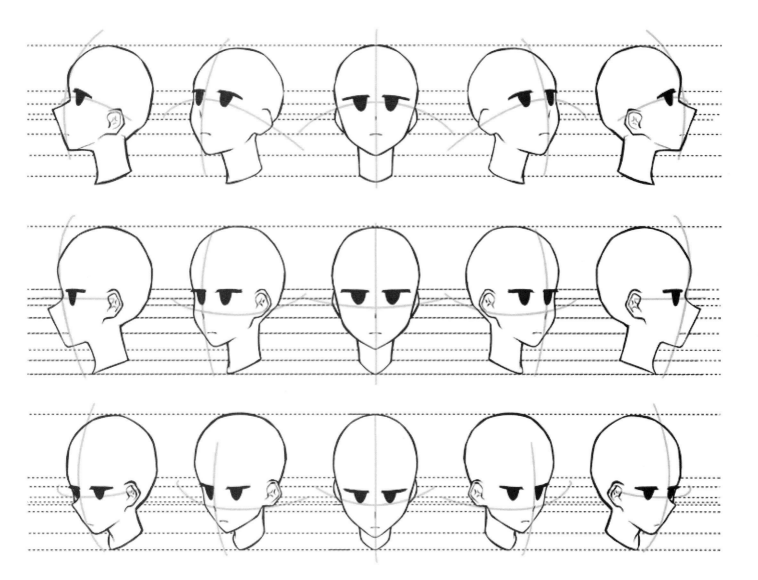

UNDERSTAND THAT THE GUIDELINES SHOULD REFLECT WHERE THE EYES (AND EVERYTHING ELSE!) WILL SIT ON THE FACE, SO IF A FACE IS LOOKING A CERTAIN DIRECTION, THE EYES WILL FACE ACCORDINGLY. THINK OF THE HEAD AS IF IT WAS A SPHERE, SO WHEREVER THE SPHERE IS TURNED, THEY WILL END UP LOOKING DIFFERENT.

FOR THE SAKE OF THIS SECTION, WE WILL ONLY BE DISCUSSING THE EFFECT ANGLES HAVE ON EYES (BUT IF YOU ARE GOING TO TAKE NOTES ON THE OTHER PARTS OF THE FACE, KUDOS TO YOU!)

THE WAY ANGLES ARE USED IN ANIME AND MANGA ARE VERY IMPORTANT, AS THEY CAN HELP ADD A CERTAIN MOOD OR FEELING TO A CHARACTER. A SNARKY-KNOW-IT-ALL TYPE MIGHT HAVE THEIR HEAD TILTED UP TO LOOK DOWN AT CHARACTERS, WHILE A MORE TIMID AND SHY CHARACTER MIGHT KEEP THEIR HEAD LOW AND AVERT THEIR GAZE AWAY.

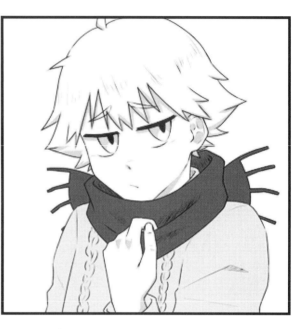

NOTICE WITH THE SNARKY CHARACTER, THAT WHEN THEIR HEAD HIS TILTED UP, THEIR GAZE WILL BLOCK SOME OF THEIR PUPILS NATURALLY, AS THE BOTTOM EYELIDS WILL BE BLOCKING THE WAY.

THE SHY CHARACTER IS TURNED AWAY, DECIDING TO HIDE THEMSELVES AWAY IN THE SAFETY OF THEIR SCARF. WITH THIS ANGLE, WE WILL SEE LESS OF THE TOPS OF THEIR PUPILS.

WHILE THEY DO HAVE A DIFFERENT EYE SHAPES THAN THE ONES WE USED BEFORE, YOU CAN STILL SEE WHERE ANGLES WILL PLAY A PART IN HOW THE EYES WILL LOOK.

DID YOU SEE HOW THE EYE THAT IS FURTHER AWAY ALMOST LOOKS NARROWER? THAT IS BECAUSE OF THE PERSPECTIVE OF THE FACE. WHEN A PART OF THE FACE IS TURNED AWAY, IT IS GOING TO BE NATURALLY PUSHED BACK FROM OUR POINT OF VIEW.

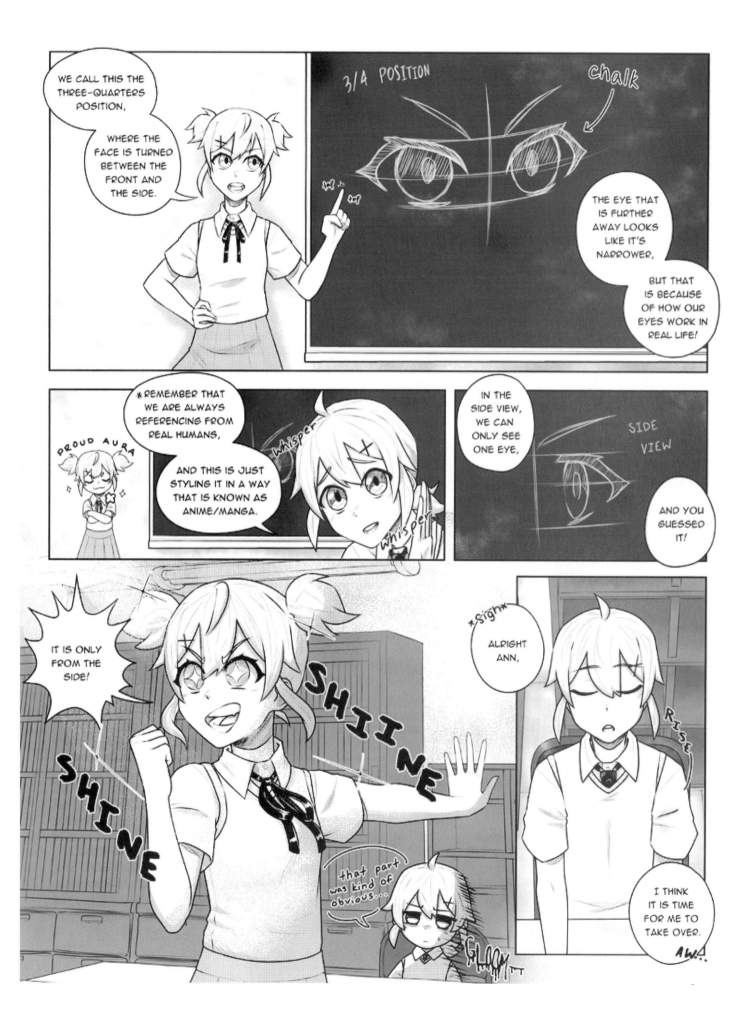

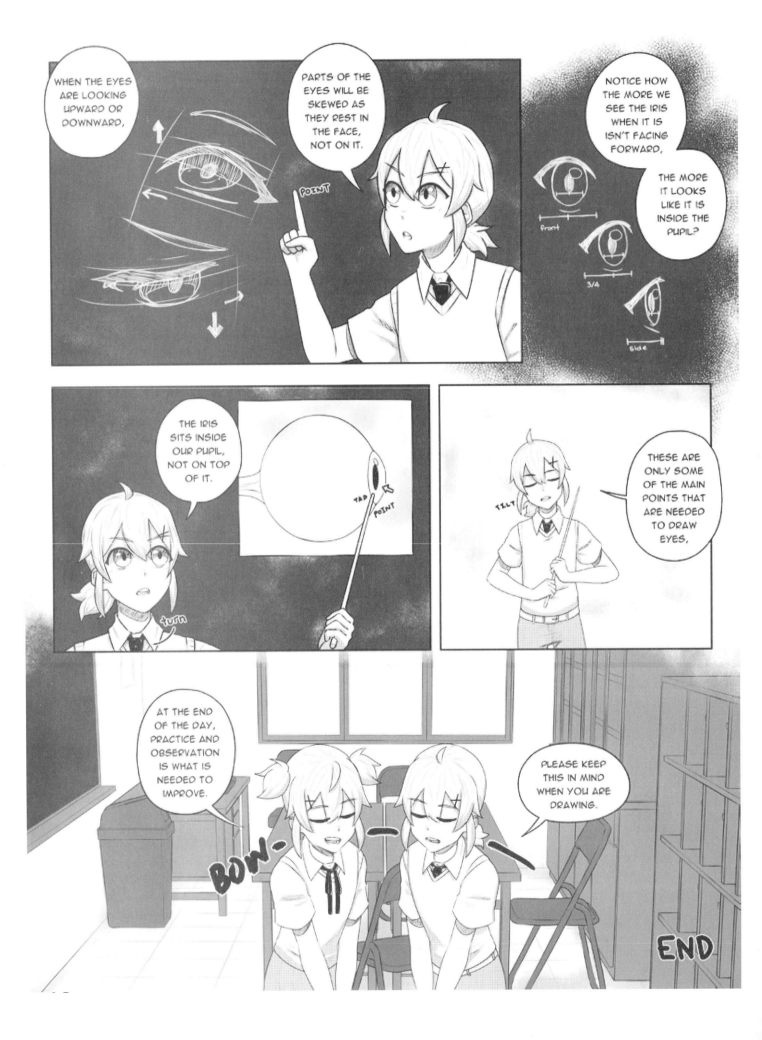

TIME TO PRACTICE!

BELOW IS A FEW SAMPLES OF HOW EYES CAN SIT ON A FACE. PLEASE TAKE NOTE THAT PRACTICING THESE DIFFERENT KINDS OF ANGLES CAN BE DIFFICULT, BUT KEEP IN MIND THAT PRACTICING WILL HELP!

ONCE YOU FEEL LIKE YOU UNDERSTAND THESE ONES AFTER TRACING THEM, USE THE NEXT PAGE TO PRACTICE SOME ANGLES ON YOUR OWN!

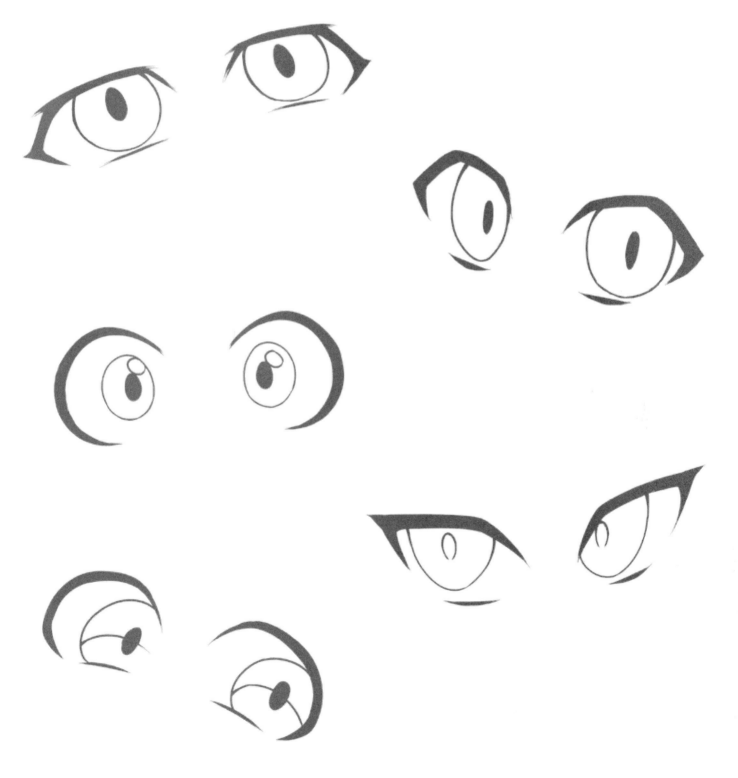

ITS NOT ONLY IMPORTANT TO READ THE STEPS, BUT TO TRY THEM OUT AS WELL! PLEASE USE THIS EMPTY SPACE TO PRACTICE THE STEPS YOU HAVE READ ON THE PREVIOUS PAGES.

CONCLUSION

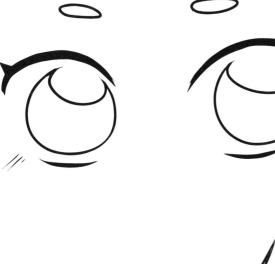

CONGRATULATIONS ON COMPLETING THE FIRST SECTION OF THIS BOOK!

THERE IS A WIDE VARIETY OF STYLES AND TECHNIQUES TO DRAW EYES. THIS CAN MAKE IT FEEL INTIMIDATING, BUT REMEMBER THAT THIS ALSO ALLOWS YOU TO CREATE YOUR OWN UNIQUE PATH TO DRAWING ANIME INSPIRED EYES.

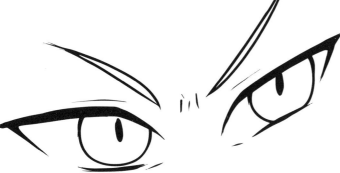

IT IS IMPORTANT TO PRACTICE DIFFERENT EYE SHAPES AND COMBINATIONS TO GET A BETTER FUNDEMENTAL UNDERSTANDING OF THEM. PERHAPS TRY PICKING YOUR FAVORITE ANIME OR MANGA CHARACTER AND STUDY THEIR EYES, AND SOON YOU WILL BE ABLE TO UNDERSTAND THE ESSENTIAL BREAKDOWN OF EYES MORE AND MORE.

MANY ARTISTS, BOTH HOBBYISTS AND PROFESSIONALS, END UP DEVELOPING THEIR OWN STEPS AND STYLE FOR DRAWING EYES OVER TIME.

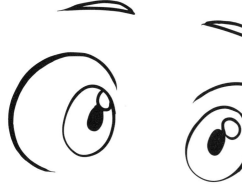

IN DUE TIME, YOU WILL START TO FORM YOUR OWN DRAWING HABITS AND METHODS, AND THIS WILL LEAD TO YOU BUILDING A STYLE OF YOUR VERY OWN.

THE JOURNEY OF DRAWINGS EYES IS NEVERENDING, BUT WITH THE RIGHT TOOLS AND PRACTICE, IT CAN BE A FUN ONE.

SECTION 2: HEADS

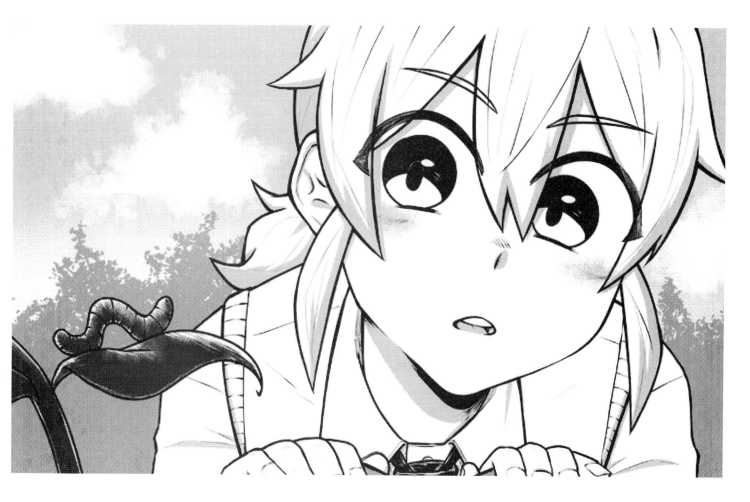

INTRODUCTION
REGULAR HEAD
CHIBI HEAD
ANGLES
PRACTICE

INTRODUCTION

HEADS ARE AN IMPORTANT PART OF THE DRAWING PROCESS, AS IT IS ONE OF THE MOST NOTABLE PARTS WE SEE IN MANGA AND ANIME. THE SHAPE AND STYLE OF THESE HEADS ARE IMPORTANT TO THE CREATION OF YOUR CHARACTERS. THE PARTS OF THE FACE, WHEN LAID ON THE HEAD, WILL BE AFFECTED BY THE SHAPE AND ANGLE OF THE HEAD IT SELF.

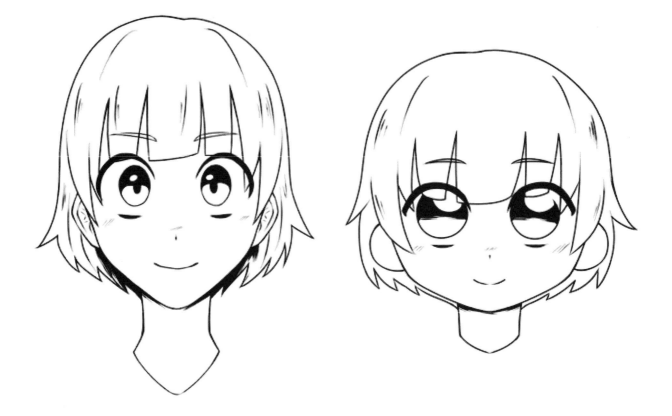

WE WILL BE LEARNING TWO STYLES OF HEADS: **REGULAR** AND **CHIBI.** THERE WILL BE SOME EXAMPLES OF DIFFERENT PARTS YOU CAN USE, BUT FOR THE STEP-BY-STEP PROCESS WE WILL ONLY BE DRAWING A SINGLE STYLE THIS TIME AROUND.

THE POSSIBILITIES ARE ENDLESS, WITH THE WIDE VARIETIES AND STYLES THAT YOU CAN USE, TO CREATE AN EFFECTIVE AND UNIQUE CHARACTER ALL ON YOUR OWN! BUT BEFORE WE CAN PUSH THE ENVELOPE, WE NEED TO LEARN THE BASICS FIRST.

IT CAN FEEL CHALLENGING TO START, BUT PLEASE FOLLOW THESE TIPS, AND THEY CAN HELP WITH YOUR GOAL OF DRAWING ANIME CHARACTERS!

REGULAR HEADS

REGULAR HEADS ARE THE DEFAULT FOR ANIME AND MANGA, WITH PROPORTIONALS THAT ARE SEMI-SIMILAR TO OUR OWN. THERE IS A LARGE VARIETY OF STYLES YOU CAN USE TO ACCOMPLISH THIS, AND OF COURSE IN THIS BOOK WE WILL BE USING A MANGA INFLUENCED STYLE.

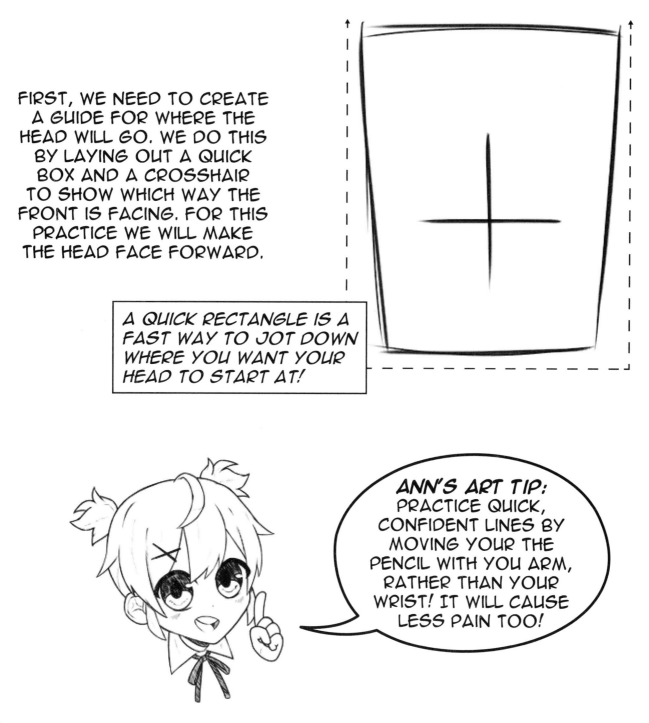

FIRST, WE NEED TO CREATE A GUIDE FOR WHERE THE HEAD WILL GO. WE DO THIS BY LAYING OUT A QUICK BOX AND A CROSSHAIR TO SHOW WHICH WAY THE FRONT IS FACING. FOR THIS PRACTICE WE WILL MAKE THE HEAD FACE FORWARD.

A QUICK RECTANGLE IS A FAST WAY TO JOT DOWN WHERE YOU WANT YOUR HEAD TO START AT!

ANN'S ART TIP: PRACTICE QUICK, CONFIDENT LINES BY MOVING YOUR THE PENCIL WITH YOU ARM, RATHER THAN YOUR WRIST! IT WILL CAUSE LESS PAIN TOO!

3

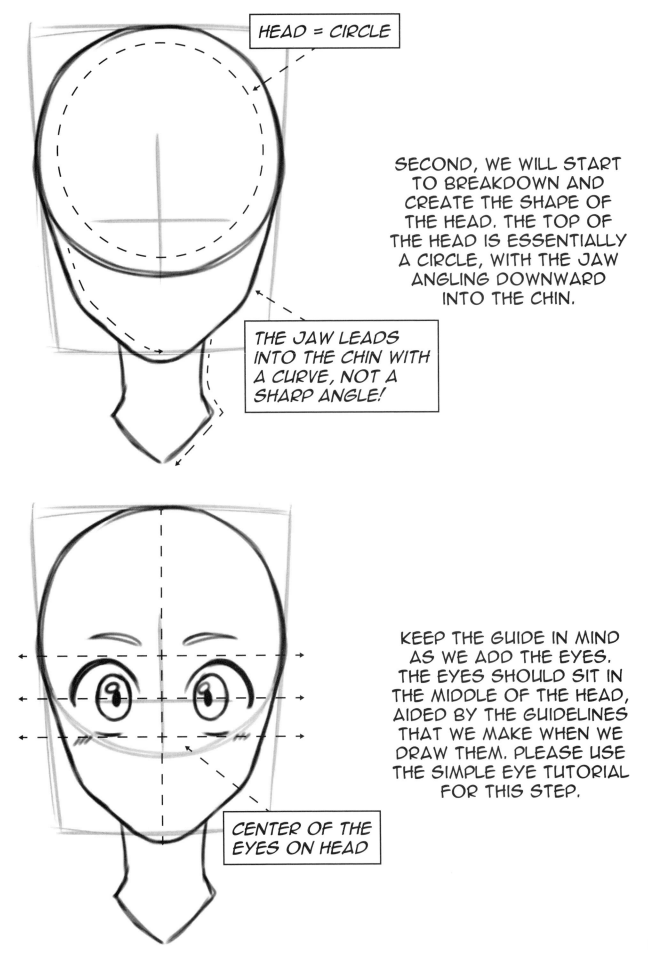

HEAD = CIRCLE

SECOND, WE WILL START TO BREAKDOWN AND CREATE THE SHAPE OF THE HEAD. THE TOP OF THE HEAD IS ESSENTIALLY A CIRCLE, WITH THE JAW ANGLING DOWNWARD INTO THE CHIN.

THE JAW LEADS INTO THE CHIN WITH A CURVE, NOT A SHARP ANGLE!

KEEP THE GUIDE IN MIND AS WE ADD THE EYES. THE EYES SHOULD SIT IN THE MIDDLE OF THE HEAD, AIDED BY THE GUIDELINES THAT WE MAKE WHEN WE DRAW THEM. PLEASE USE THE SIMPLE EYE TUTORIAL FOR THIS STEP.

CENTER OF THE EYES ON HEAD

4

THE MOUTH SITS ON THE LOWER THIRD OF THE HEAD. THE STYLE OF THE LIPS IS UP TO THE ARTIST, BUT FOR THIS ONE WE WILL USE A SIMPLE LINE.

THE MOUTH CAN MOVE BASED ON THE TYPE OF EXPRESSIONS, BUT FOR THE DEFAULT PLACEMENT IT WILL SIT HERE.

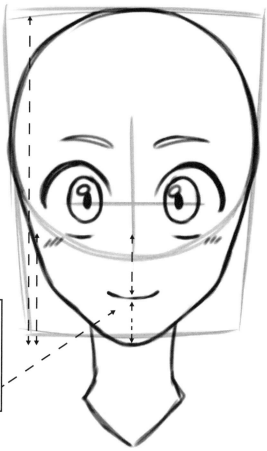

THE NOSE IS IN-BETWEEN THE EYES AND LIPS, AND DEPENDING ON THE STYLE IT CAN AFFECT HOW MUCH OF IT IS SHOWN. WE WILL USE ANOTHER SIMPLE LINE AND SOME SKETCH MARKS TO SHOW THE TOP OF THE NOSE.

THE NOSE IS EASY TO PUT IF YOU REMEMBER THAT IT IS EQUAL DISTANCE FROM THE EYES AND MOUTH!

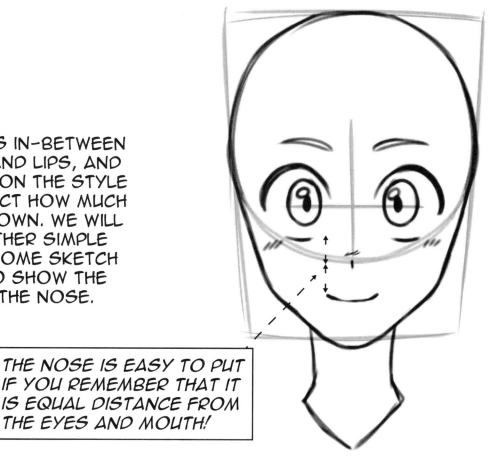

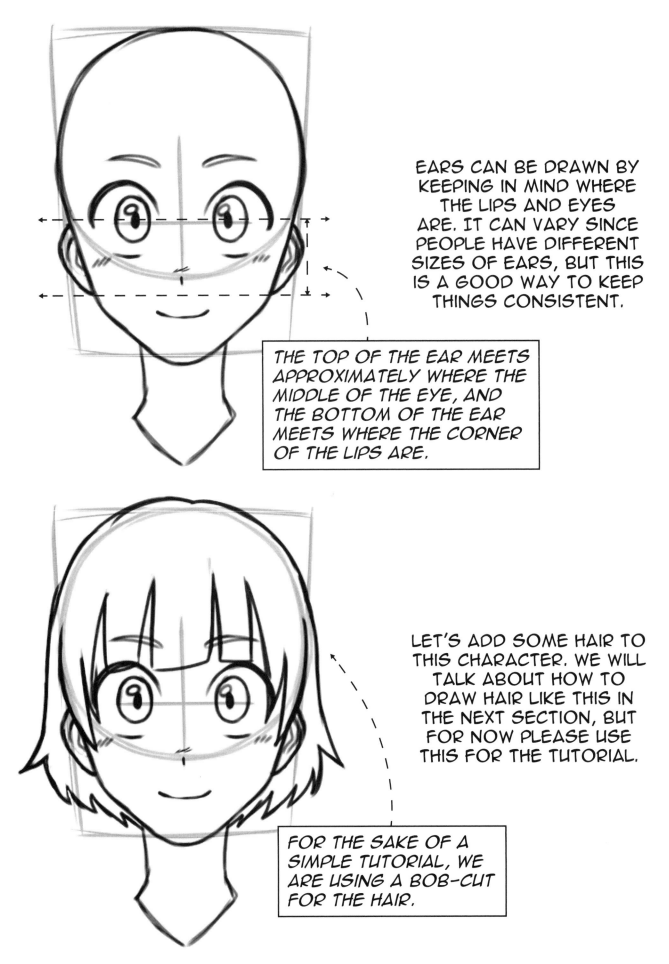

EARS CAN BE DRAWN BY KEEPING IN MIND WHERE THE LIPS AND EYES ARE. IT CAN VARY SINCE PEOPLE HAVE DIFFERENT SIZES OF EARS, BUT THIS IS A GOOD WAY TO KEEP THINGS CONSISTENT.

THE TOP OF THE EAR MEETS APPROXIMATELY WHERE THE MIDDLE OF THE EYE, AND THE BOTTOM OF THE EAR MEETS WHERE THE CORNER OF THE LIPS ARE.

LET'S ADD SOME HAIR TO THIS CHARACTER. WE WILL TALK ABOUT HOW TO DRAW HAIR LIKE THIS IN THE NEXT SECTION, BUT FOR NOW PLEASE USE THIS FOR THE TUTORIAL.

FOR THE SAKE OF A SIMPLE TUTORIAL, WE ARE USING A BOB-CUT FOR THE HAIR.

6

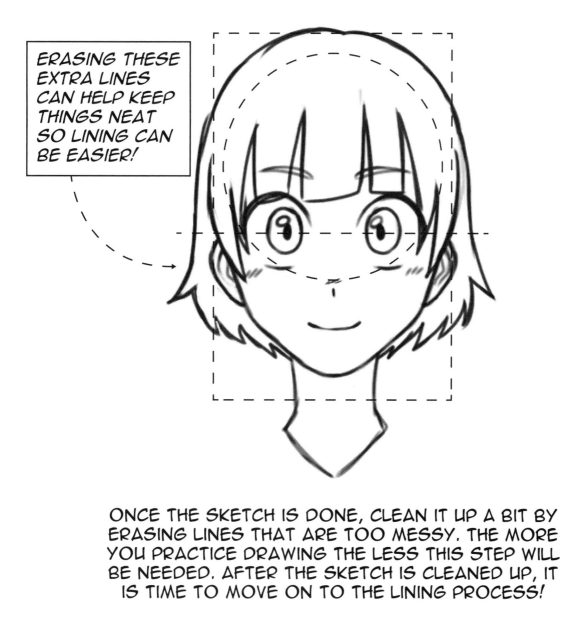

ERASING THESE EXTRA LINES CAN HELP KEEP THINGS NEAT SO LINING CAN BE EASIER!

ONCE THE SKETCH IS DONE, CLEAN IT UP A BIT BY ERASING LINES THAT ARE TOO MESSY. THE MORE YOU PRACTICE DRAWING THE LESS THIS STEP WILL BE NEEDED. AFTER THE SKETCH IS CLEANED UP, IT IS TIME TO MOVE ON TO THE LINING PROCESS!

IME'S ART TIP: MANGA ARTISTS AND ANIMATORS RELY ON QUICK AND ACCURATE STROKES, WHICH IS SOMETHING YOU CAN ONLY ACHIEVE BY PRACTICING.

ITS NOT ONLY IMPORTANT TO READ THE STEPS, BUT TO TRY THEM OUT AS WELL! PLEASE USE THIS EMPTY SPACE TO PRACTICE THE STEPS YOU HAVE READ ON THE PREVIOUS PAGES.

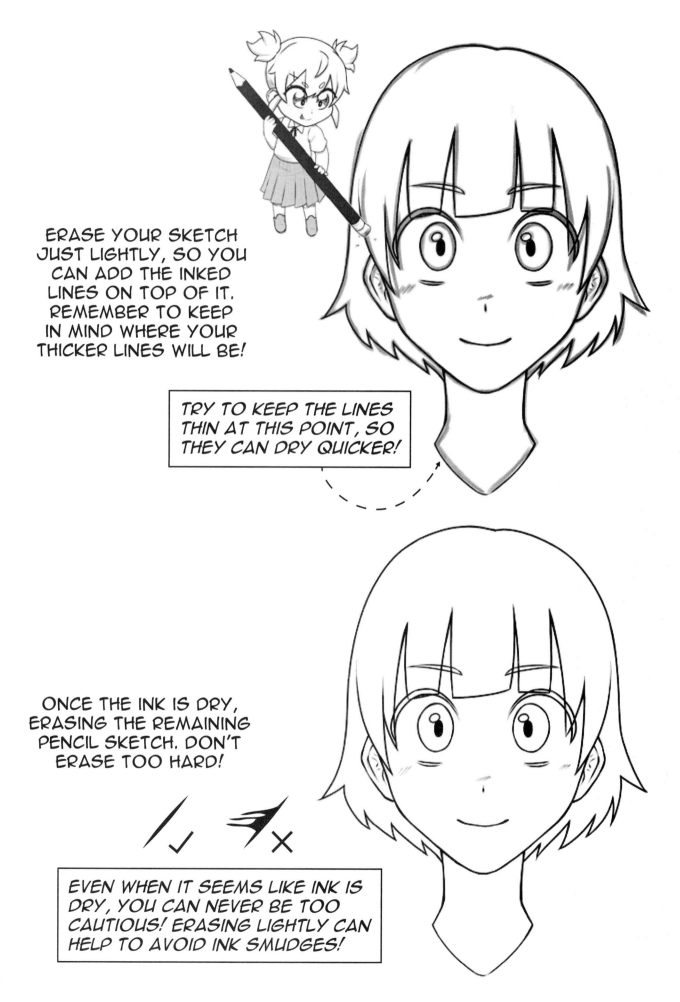

ERASE YOUR SKETCH JUST LIGHTLY, SO YOU CAN ADD THE INKED LINES ON TOP OF IT. REMEMBER TO KEEP IN MIND WHERE YOUR THICKER LINES WILL BE!

TRY TO KEEP THE LINES THIN AT THIS POINT, SO THEY CAN DRY QUICKER!

ONCE THE INK IS DRY, ERASING THE REMAINING PENCIL SKETCH. DON'T ERASE TOO HARD!

EVEN WHEN IT SEEMS LIKE INK IS DRY, YOU CAN NEVER BE TOO CAUTIOUS! ERASING LIGHTLY CAN HELP TO AVOID INK SMUDGES!

9

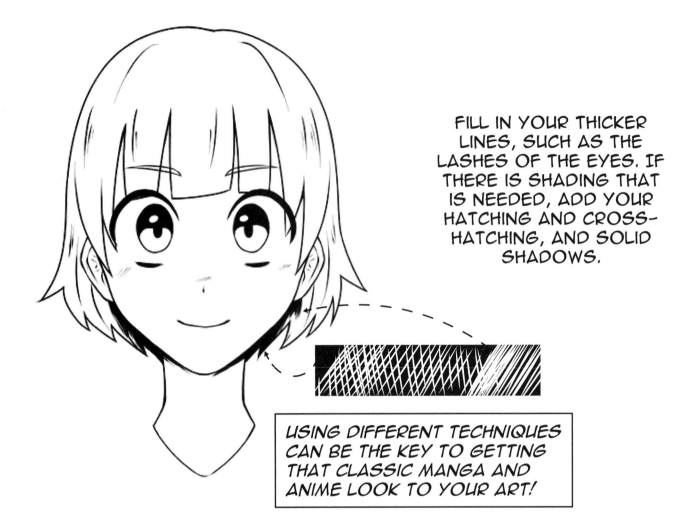

FILL IN YOUR THICKER LINES, SUCH AS THE LASHES OF THE EYES. IF THERE IS SHADING THAT IS NEEDED, ADD YOUR HATCHING AND CROSS-HATCHING, AND SOLID SHADOWS.

USING DIFFERENT TECHNIQUES CAN BE THE KEY TO GETTING THAT CLASSIC MANGA AND ANIME LOOK TO YOUR ART!

CONGRATULATIONS, NOW YOU HAVE FINISHED DRAWING A REGULAR ANIME HEAD! PLEASE USE THESE STEPS TO PRACTICE IN THE FUTURE!

ANN'S ART TIP: USING DIFFERENT TECHNIQUES AND STYLES OF SHADING IS KEY TO MAKING DIFFERENT PARTS OF THE BODY LOOK UNIQUE.

ITS NOT ONLY IMPORTANT TO READ THE STEPS, BUT TO TRY THEM OUT AS WELL! PLEASE USE THIS EMPTY SPACE TO PRACTICE THE STEPS YOU HAVE READ ON THE PREVIOUS PAGES.

CHIBI HEADS

CHIBI HEADS ARE MORE SIMPLE IN DETAIL, BUT IN ORDER TO GET THAT "KAWAII" LOOK, THERE ARE SOME DOS AND DON'TS TO AVOID IT LOOKING LIKE AN ODD HEAD ON A TINY BODY. THE KEY TO THIS IS TO SQUASH AND SIMPLIFY BODY, AND SPECIFICALLY THE HEAD IN THIS SITUATION.

LETS COMPARE THE REGULAR HEAD TO THE CHIBI HEAD, AND POINT OUT SOME OBVIOUS, AND NOT SO OBVIOUS DIFFERENCES BELOW.

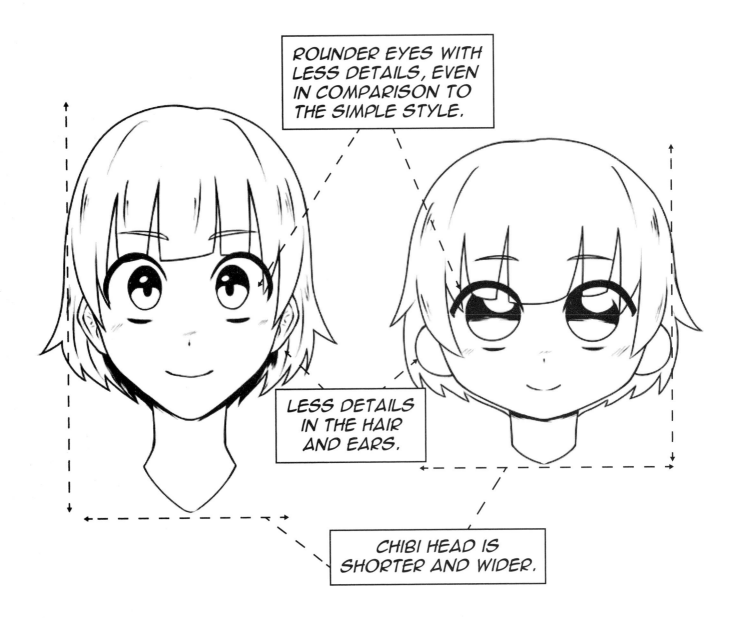

ROUNDER EYES WITH LESS DETAILS, EVEN IN COMPARISON TO THE SIMPLE STYLE.

LESS DETAILS IN THE HAIR AND EARS.

CHIBI HEAD IS SHORTER AND WIDER.

WITHOUT THESE DIFFERENCES, THE HEAD WOULD LOOK MORE CREEPY THAN CUTE ON A TINY BODY. LETS DO OUR BEST TO LEARN THE DIFFERENT TECHNIQUES NEEDED TO DRAW A CUTE CHIBI STYLED HEAD!

SIMILAR TO REGULAR HEAD, WE WILL CREATE A QUICK BOX AND CROSSHAIR TO INDICATE THE HEAD AND DIRECTION, ONLY THIS TIME IT SHOULD BE MORE OF A SQUARE THAN A RECTANGLE SINCE CHIBI HEADS ARE ROUNDER.

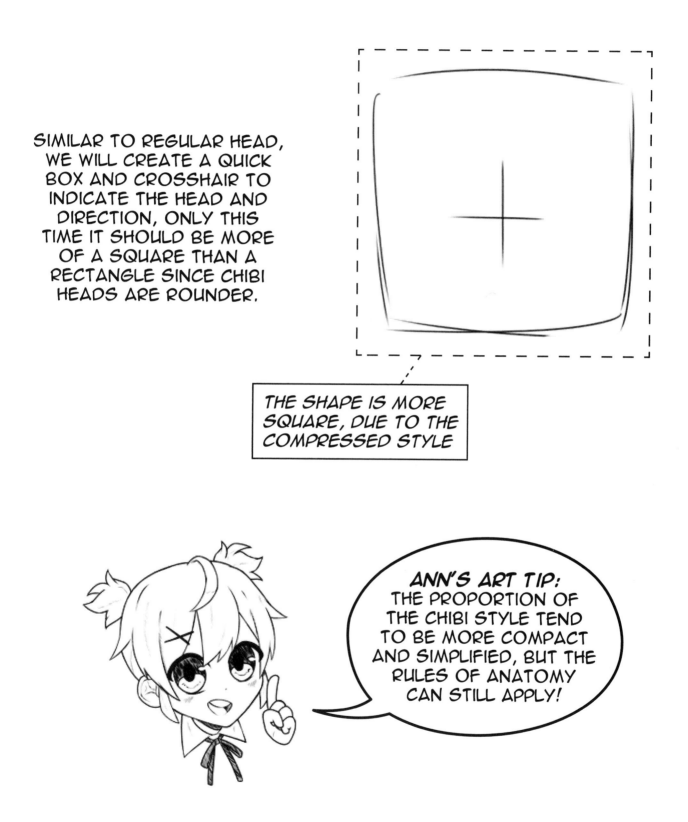

THE SHAPE IS MORE SQUARE, DUE TO THE COMPRESSED STYLE

ANN'S ART TIP: THE PROPORTION OF THE CHIBI STYLE TEND TO BE MORE COMPACT AND SIMPLIFIED, BUT THE RULES OF ANATOMY CAN STILL APPLY!

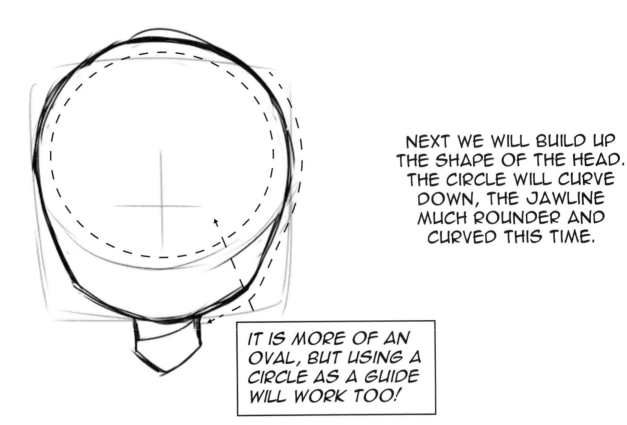

NEXT WE WILL BUILD UP THE SHAPE OF THE HEAD. THE CIRCLE WILL CURVE DOWN, THE JAWLINE MUCH ROUNDER AND CURVED THIS TIME.

IT IS MORE OF AN OVAL, BUT USING A CIRCLE AS A GUIDE WILL WORK TOO!

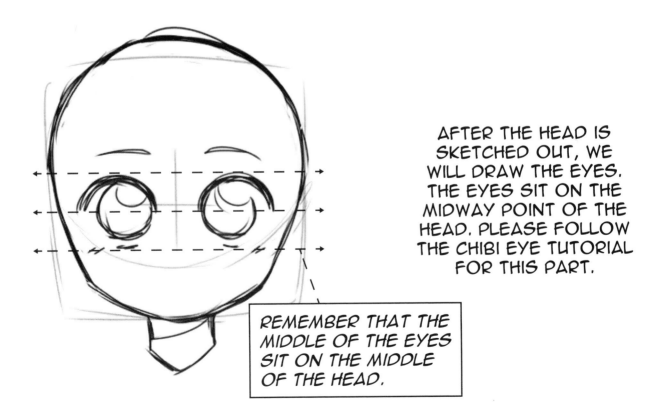

AFTER THE HEAD IS SKETCHED OUT, WE WILL DRAW THE EYES. THE EYES SIT ON THE MIDWAY POINT OF THE HEAD. PLEASE FOLLOW THE CHIBI EYE TUTORIAL FOR THIS PART.

REMEMBER THAT THE MIDDLE OF THE EYES SIT ON THE MIDDLE OF THE HEAD.

14

THE MOUTH IS PLACED
IN THE LOWER HALF OF
THE FACE. SINCE THIS
IS CHIBI, PLEASE KEEP
THIS AS A SIMPLE LINE.

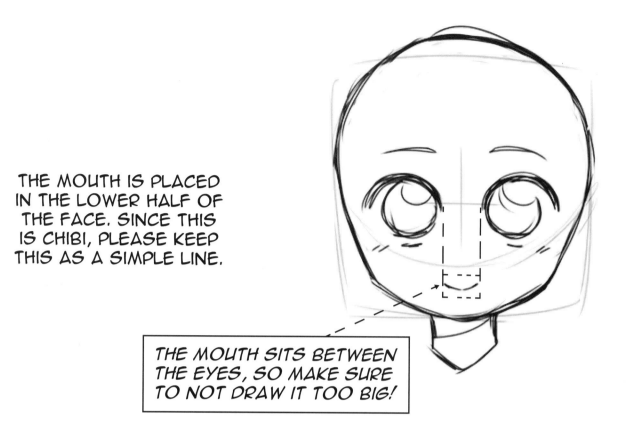

THE MOUTH SITS BETWEEN
THE EYES, SO MAKE SURE
TO NOT DRAW IT TOO BIG!

THE NOSE, WHEN
ADDED TO A CHIBI
FACE, SHOULD BE
SIMPLIFIED. USING A
SMALL LINE CAN BE
EFFECTIVE FOR THIS.

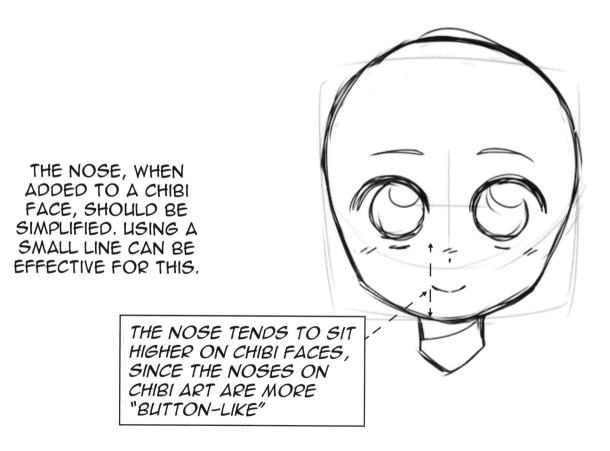

THE NOSE TENDS TO SIT
HIGHER ON CHIBI FACES,
SINCE THE NOSES ON
CHIBI ART ARE MORE
"BUTTON-LIKE"

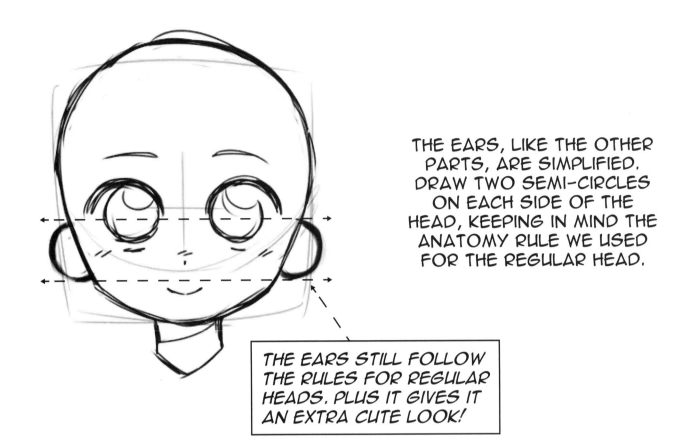

THE EARS, LIKE THE OTHER PARTS, ARE SIMPLIFIED. DRAW TWO SEMI-CIRCLES ON EACH SIDE OF THE HEAD, KEEPING IN MIND THE ANATOMY RULE WE USED FOR THE REGULAR HEAD.

THE EARS STILL FOLLOW THE RULES FOR REGULAR HEADS. PLUS IT GIVES IT AN EXTRA CUTE LOOK!

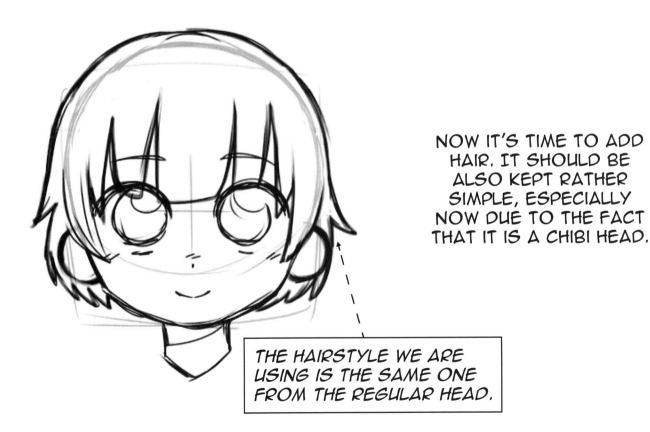

NOW IT'S TIME TO ADD HAIR. IT SHOULD BE ALSO KEPT RATHER SIMPLE, ESPECIALLY NOW DUE TO THE FACT THAT IT IS A CHIBI HEAD.

THE HAIRSTYLE WE ARE USING IS THE SAME ONE FROM THE REGULAR HEAD.

16

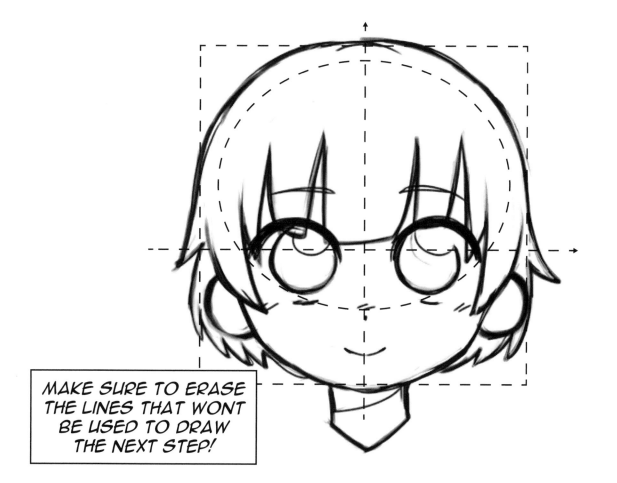

MAKE SURE TO ERASE THE LINES THAT WONT BE USED TO DRAW THE NEXT STEP!

ONCE YOU HAVE YOUR ROUGH SKETCH LAID OUT, IT IS TIME TO CLEAN UP THE GUIDELINES AND LINES THAT MAKE THE DRAWING HARDER TO INK. ONCE THAT IS DONE, IT IS TIME TO WORK ON THE LINEART!

IME'S ART TIP: WHEN YOUR SKETCH IS REALLY MESSY, IT IS GOOD TO KEEP IT LIGHT! THIS ALLOWS FOR AN EASIER TIME WHEN YOU NEED TO ERASE IT.

ITS NOT ONLY IMPORTANT TO READ THE STEPS, BUT TO TRY THEM OUT AS WELL! PLEASE USE THIS EMPTY SPACE TO PRACTICE THE STEPS YOU HAVE READ ON THE PREVIOUS PAGES.

ERASE YOUR SKETCH
JUST LIGHTLY, SO
YOU CAN ADD THE
INK ON TOP OF IT.

REMEMBER TO AVOID
THICK LINES DURING THIS
STEP TO MAKE THE NEXT
STEP ALOT EASIER!

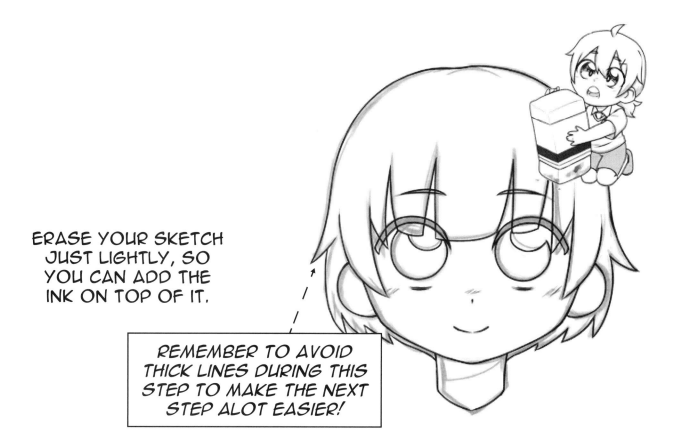

NEXT, WE WILL LAY
DOWN THE BASIC
LINES. REMEMBER
TO KEEP IN MIND
THE LINE WIDTH!

IF YOU ARE WORRIED ABOUT
DRAWING THE THICK LINES,
TRY OUTLINING THE THOSE
AREAS FIRST!

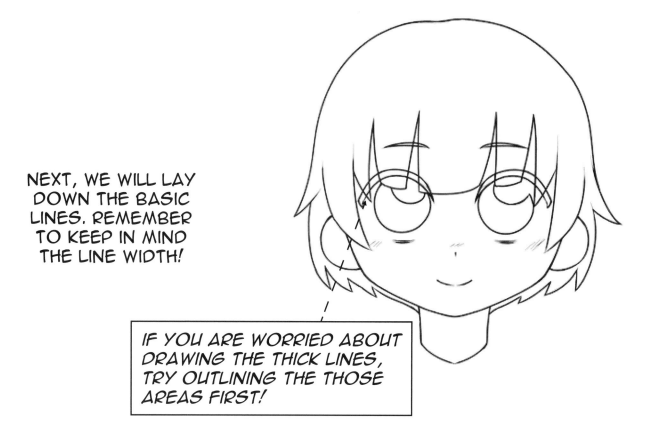

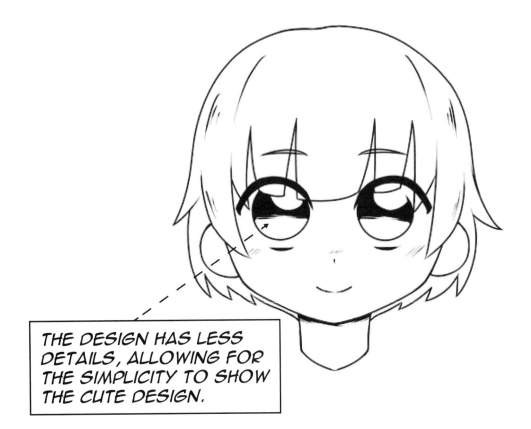

THE DESIGN HAS LESS DETAILS, ALLOWING FOR THE SIMPLICITY TO SHOW THE CUTE DESIGN.

IF THERE IS SHADING THAT IS NEEDED, ADD YOUR HATCHING AND CROSS-HATCHING. CHIBI STYLES TEND TO HAVE LESS HATCHING, AND MORE SOLID TONES FOR SHADING.

ANN'S ART TIP: CHARACTERS THAT HAVE MORE COMPLICATED DESIGNS STILL FOLLOW THESE RULES, BY TAKING ADVANTAGE OF LINEART TECHNIQUES!

20

ITS NOT ONLY IMPORTANT TO READ THE STEPS, BUT TO TRY THEM OUT AS WELL! PLEASE USE THIS EMPTY SPACE TO PRACTICE THE STEPS YOU HAVE READ ON THE PREVIOUS PAGES.

ANGLES

SIMILAR TO THE EYES SECTION, WE WILL BE LOOKING AT HOW THE FACE AND HEAD INTERACT BASED ON WHAT ANGLE IT IS DRAWN FROM! IT CAN BE CHALLENGING TO DRAW A HEAD IN MORE DYNAMIC ANGLES, BUT IF YOU BREAK DOWN THE HEADS INTO UNDERSTANDABLE SHAPES AND RULES, YOU CAN BEGIN TO DRAW THE HEAD IN VIRTUALLY ANY ANGLE YOU NEED! FOR A BEGINNERS BOOK, WE WILL START WITH FOUR BASIC DIRECTIONS:

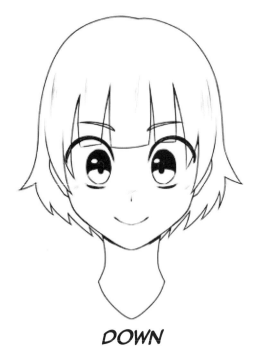

DOWN

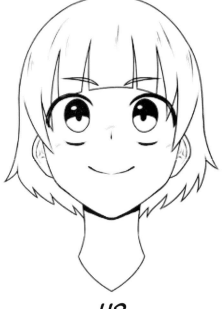

UP

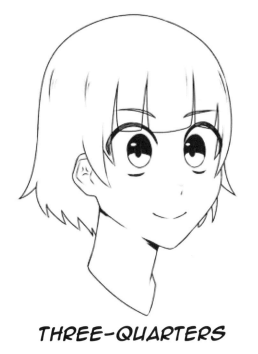

THREE-QUARTERS

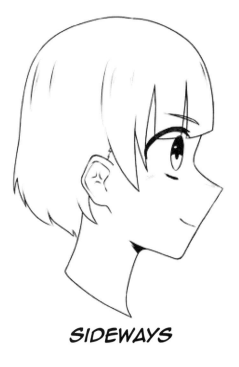

SIDEWAYS

22

A HEAD, WHEN ANGLED DOWN, HAS THE FACE RESTING ON THE LOWER HALF OF IT. LET'S TAKE A CLOSER LOOK AT THE SHAPES AND PLACEMENT SO WE CAN UNDERSTAND HOW TO DRAW A HEAD AT A DOWNWARD ANGLE.

THE EARS WILL SEEM TO LOOK HIGHER, BUT IF YOU USE A CURVED LINE (SIMILAR TO THE GUIDELINES FOR THE EYE TUTORIAL) YOU CAN SEE IT WILL STILL LINE UP WITH THE EYES AND MOUTH.

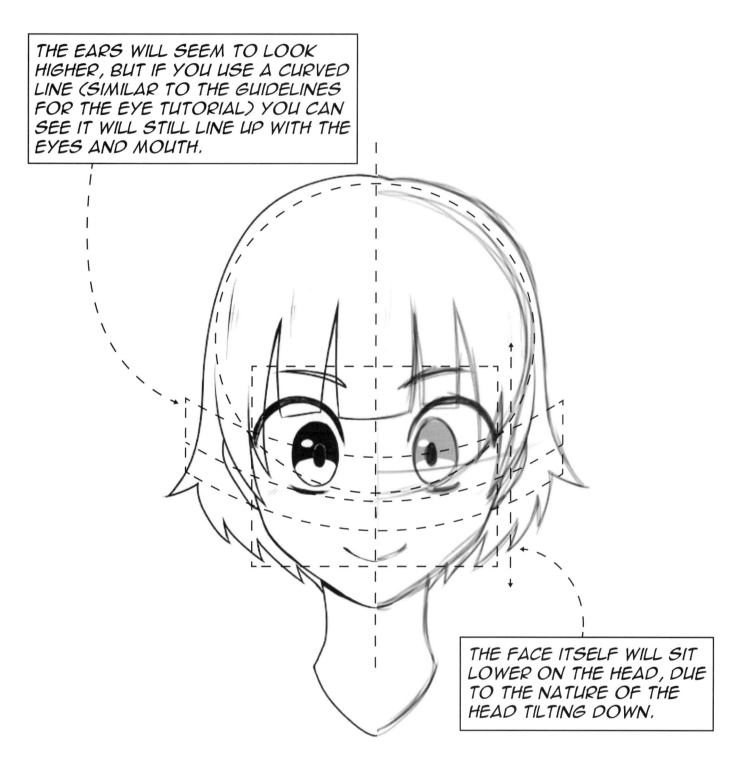

THE FACE ITSELF WILL SIT LOWER ON THE HEAD, DUE TO THE NATURE OF THE HEAD TILTING DOWN.

WHEN A CHARACTER IS LOOKING UP IT CAN LOOK A LITTLE ODD, BUT THERE ARE TRICKS YOU CAN USE SO IT CAN LOOK GOOD WHILE KEEPING IT SEMI-ACCURATE. LOOKING AT THE BREAKDOWN OF THE FACE CAN HELP WITH DRAWING YOUR OWN ANIME CHARACTER'S HEAD LOOKING UP.

THE EARS WILL SEEM TO LOOK LOWER, BUT IF YOU USE A CURVED GUIDELINE (BASED ON THE ANGLE THAT IS USED) YOU CAN SEE IT WILL STILL LINE UP WITH THE EYES AND MOUTH.

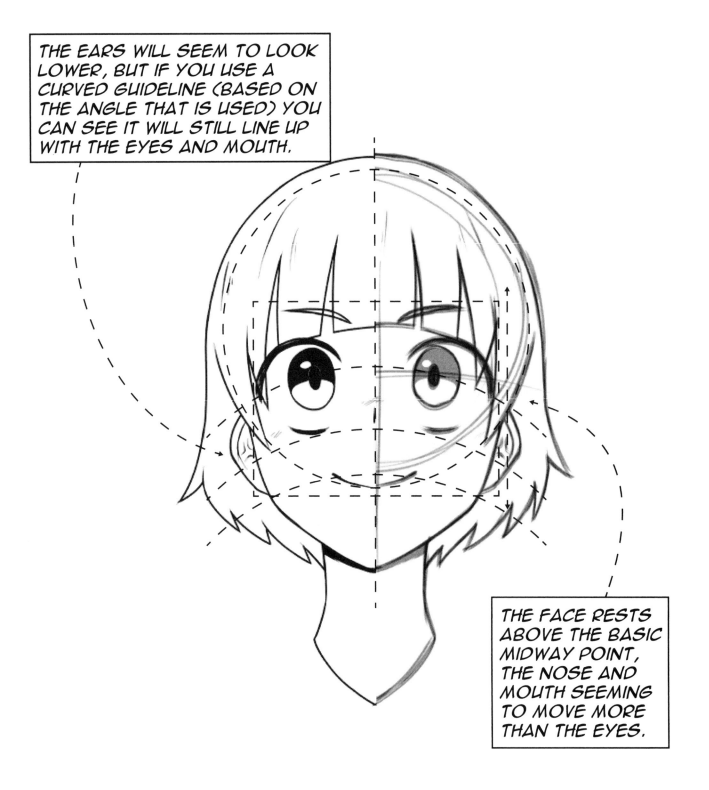

THE FACE RESTS ABOVE THE BASIC MIDWAY POINT, THE NOSE AND MOUTH SEEMING TO MOVE MORE THAN THE EYES.

THIS CAN BE TRICKY FOR SOME ARTISTS, BUT AS LONG AS YOU KEEP THE RULES OF ANATOMY WE TALKED ABOUT IN MIND IT CAN HELP A LOT. IT CAN HELP TO PRACTICE SIDE VIEWS AND FIGURE OUT WHAT METHODS OR STYLES YOU LIKE BEST.

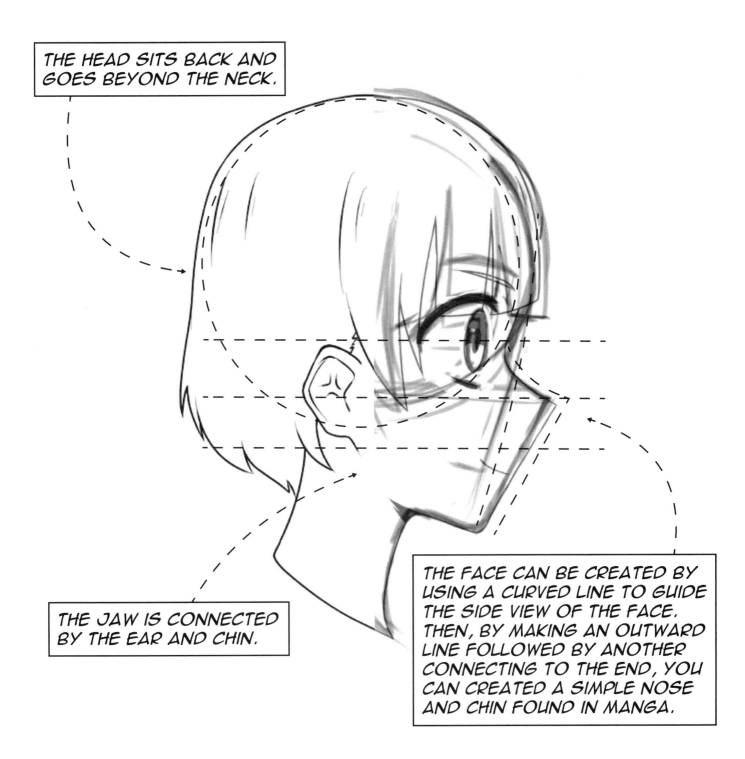

THE HEAD SITS BACK AND GOES BEYOND THE NECK.

THE JAW IS CONNECTED BY THE EAR AND CHIN.

THE FACE CAN BE CREATED BY USING A CURVED LINE TO GUIDE THE SIDE VIEW OF THE FACE. THEN, BY MAKING AN OUTWARD LINE FOLLOWED BY ANOTHER CONNECTING TO THE END, YOU CAN CREATED A SIMPLE NOSE AND CHIN FOUND IN MANGA.

SIMILAR TO THE RULES FOR THE EYES, PARTS OF THE FACE WILL
BE FARTHER AWAY, BEING HIDDEN BY OTHER PARTS OF THE FACE
ITSELF. THE MOUTH AND NOSE WILL OFF CENTER, LEANING TOWARDS
THE DIRECTION THE FACE IS POINTING. LET'S TAKE A CLOSER LOOK
AT HOW WE CAN ACHIEVE THIS ANGLE.

IF WE BREAK DOWN THE
SHAPES, WE CAN SEE
HOW THE CIRCLE ALMOST
HANGS OFF, DUE TO THE
FACT THAT THE BACK OF
OUR HEADS HAVE DEPTH.

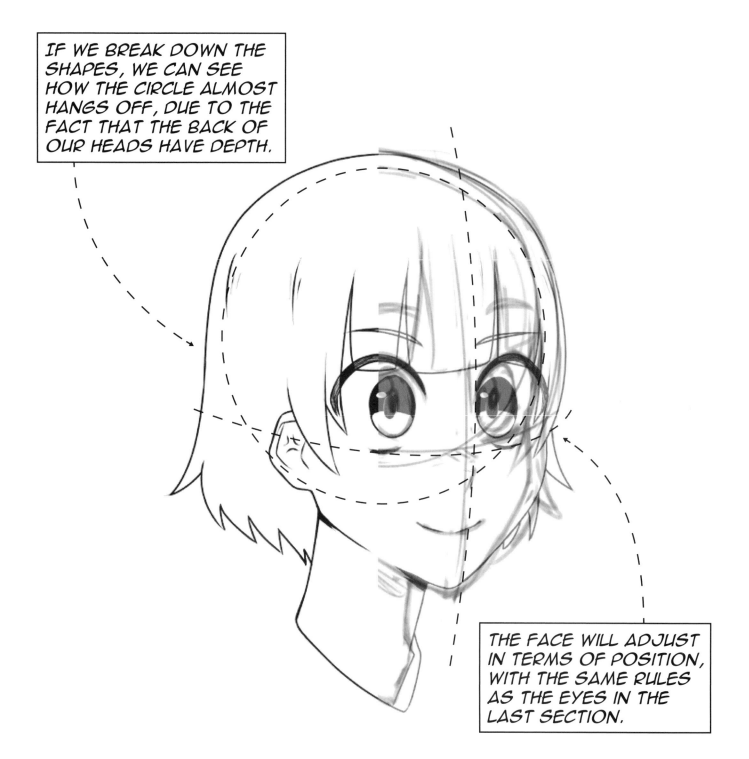

THE FACE WILL ADJUST
IN TERMS OF POSITION,
WITH THE SAME RULES
AS THE EYES IN THE
LAST SECTION.

26

TIME TO PRACTICE!

HERE ARE A COUPLE PRACTICE PAGES TO GET USED TO DRAWING THE HEAD (AND FACE) IN DIFFERENT ANGLES. PLEASE USE THESE TO AID IN YOUR JOURNEY OF DRAWING HEADS.

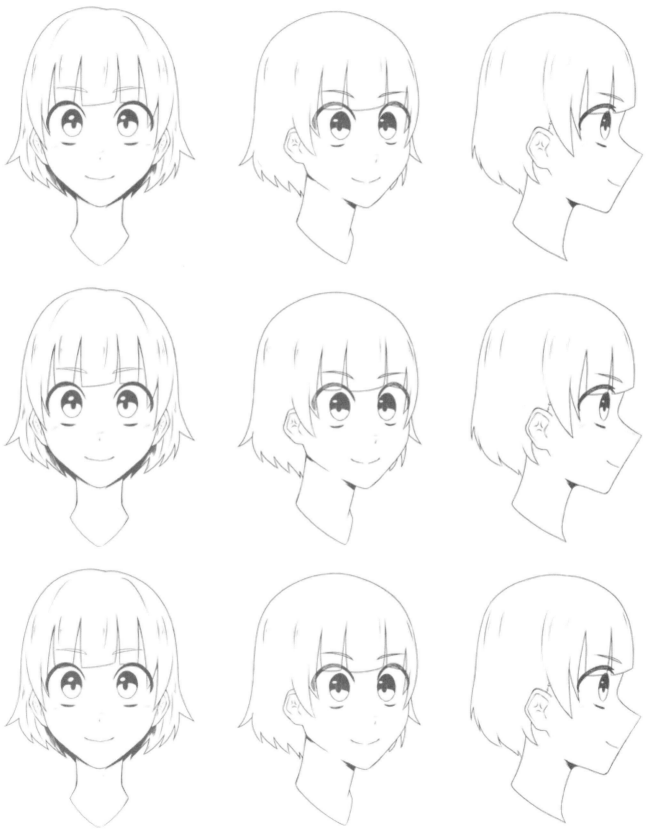

TIME TO PRACTICE!

HERE ARE A COUPLE PRACTICE PAGES TO GET USED TO DRAWING THE HEAD (AND FACE) IN DIFFERENT ANGLES. PLEASE USE THESE TO AID IN YOUR JOURNEY OF DRAWING HEADS.

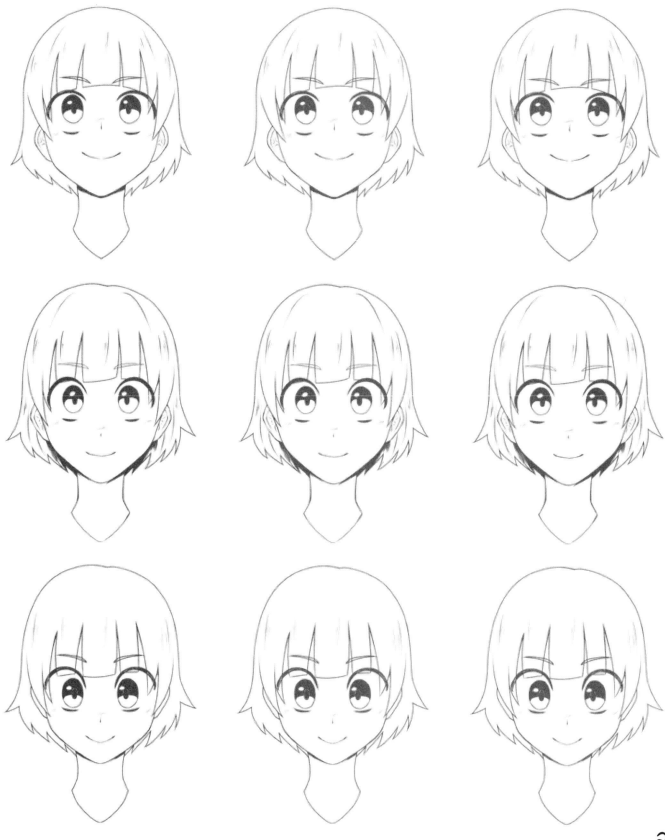

ITS NOT ONLY IMPORTANT TO READ THE STEPS, BUT TO TRY THEM OUT AS WELL! PLEASE USE THIS EMPTY SPACE TO PRACTICE THE STEPS YOU HAVE READ ON THE PREVIOUS PAGES.

CONCLUSION

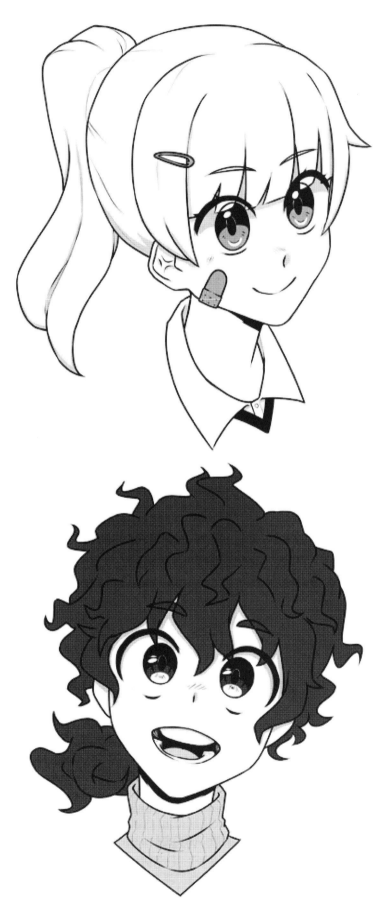

CONGRATULATIONS ON COMPLETING THE HEAD SECTION OF THIS BOOK! YOU ARE NOW ANOTHER STEP CLOSER ON YOUR JOURNEY OF DRAWING ANIME AND MANGA CHARACTERS.

HEADS ARE THE TEMPLATE NEEDED TO HOLD IMPORTANT CHARACTERISTICS OF YOUR CHARACTERS, AND ALLOWS FOR YOUR CHARACTERS TO HAVE A UNIQUE IDENTITY. WHEN YOUR CHARACTERS WEAR ALL THE SAME STYLE OF CLOTHING (LIKE IN A SCHOOL SETTING WHERE THEY ALL WEAR UNIFORMS), IT IS THE HEAD THAT SETS THEM APART.

LEARNING HOW TO DRAW HEADS FOR YOUR CHARACTERS CAN HELP IMPROVE YOUR JOURNEY AS A BEGINNER. THE KEY TO LEARNING AND GROWING IS TO PRACTICE AND STUDY THE TYPE OF HEADS YOU WANT TO DRAW!

WITH THIS SECTION NOW COMPLETED, YOU HAVE THE BASE TO CREATE ANY KIND OF CHARACTER DESIGN YOU WANT! AS LONG AS YOU FOLLOW THE BASIC RULES AND ANATOMY, THE SKY IS THE LIMIT WHEN IT COMES TO THE VARYING AMOUNT OF DIFFERENT DESIGNS AND LOOKS YOU CAN GIVE YOUR CHARACTER.

SECTION 3: EXPRESSIONS

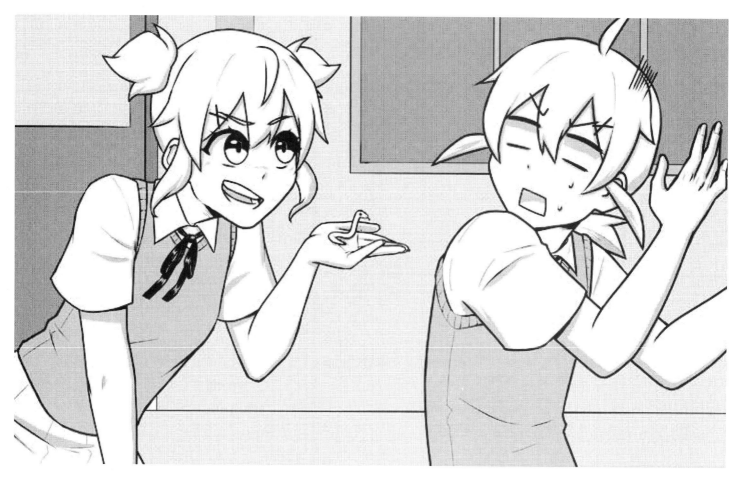

INTRODUCTION

EXPRESSIONS ARE WHAT BRING OUR CHARACTERS ALIVE AND SHOW THEIR PERSONALITIES. THE WAY A CHARACTER SHOWS THEMSELVES IS CRUCIAL TO DEVELOPING THE STORY AND THEIR INTERACTIONS WITH OTHERS. THE WAY A CHARACTERS EXPRESSES THEMSELVES IS KEY TO EFFECTIVE ANIME AND MANGA STORIES, OTHERWISE A PLAIN FACE CAN GET BORING PRETTY EASILY, AND CAN EVEN LEAD TO LESS VISUALLY INTERESTING DRAWINGS.

FOR THIS SECTION WE WILL GO OVER SOME BASIC EXPRESSIONS YOU CAN SEE IN ANY MANGA/ANIME:

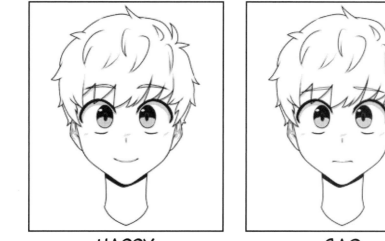

HAPPY SAD

ANGRY SHOCKED CONFUSED

WE WILL GO OVER THESE EXPRESSIONS IN THEIR MOST BASIC FORM, AND THEN WE WILL PUSH THEM FURTHER TO SHOW HOW THEY HAVE AN AFFECT ON THE CHARACTER'S FACE.

THIS SECTION WILL BE MORE OF A BREAKDOWN AND ANALYSIS, RATHER THAN A STEP BY STEP PROCESS, SINCE WE HAVE COVERED HOW TO DRAW A FACE IN THE PREVIOUS PARTS.

HAPPY

ONE OF OUR MOST BASIC AND WARMEST EXPRESSIONS, A HAPPY LOOK ON A FACE IS ALWAYS A GOOD WAY TO SHOW POSITIVE EXPERIENCES WITH THE CHARACTERS ON THE PAGE. WHILE IT IS EASY TO MAKE A SIMPLE SMILE, WE ARE GOING TO BREAK DOWN HOW TO MAKE AN EFFECTIVE HAPPY LOOK ON THIS FACE, AND HOW TO PUSH THE EMOTION FURTHER IN ORDER TO CREATE A MORE DISTINGUISHABLE EXPRESSION.

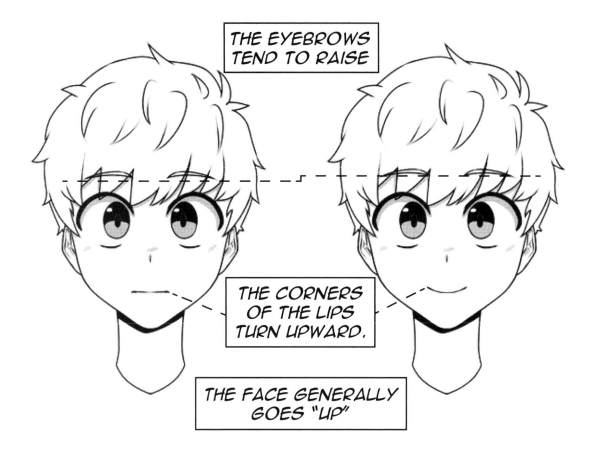

THE EYEBROWS TEND TO RAISE

THE CORNERS OF THE LIPS TURN UPWARD.

THE FACE GENERALLY GOES "UP"

THE BIGGER SOMEONE SMILES, THE NARROWER THEIR EYES CAN GET. YOU CAN SEE THIS IN THE LOWER EYELID.

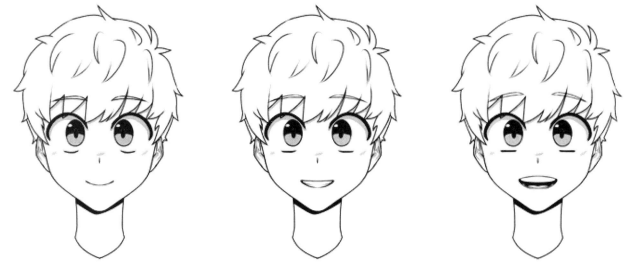

ITS NOT ONLY IMPORTANT TO READ THE NOTES, BUT TO TRY THEM OUT AS WELL! PLEASE USE THIS EMPTY SPACE TO PRACTICE THE THINGS YOU HAVE READ ON THE PREVIOUS PAGES.

SAD

WHEN SOMETHING TRAGIC OR UPSETTING HAPPENS IN A MANGA OR ANIME STORY, A CHARACTER WITH A NEUTRAL EXPRESSION DOESN'T DO MUCH TO SHOW THEIR SADNESS. BUT IF WE UNDERSTAND THE BASICS TO MAKING A CHARACTER SHOW HOW SAD THEY ARE, WE CAN PUSH THOSE LIMITS AND SHOW EVEN STRONGER FEELINGS SO IT CAN FEEL MORE REAL!

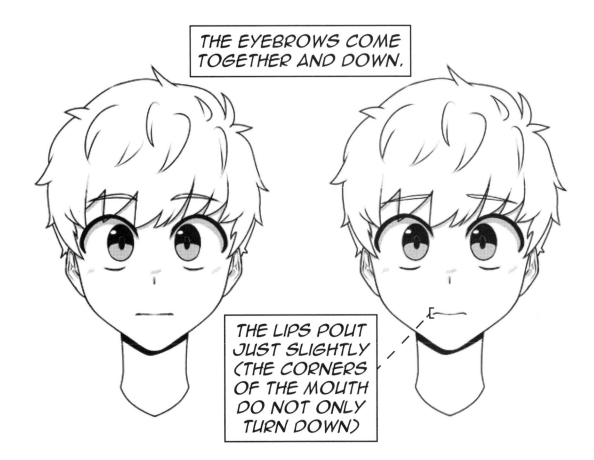

THE EYEBROWS COME TOGETHER AND DOWN.

THE LIPS POUT JUST SLIGHTLY (THE CORNERS OF THE MOUTH DO NOT ONLY TURN DOWN)

THE MORE SOMEONE FEELS SAD, TEARS ARE MORE LIKELY TO APPEAR, AND THE EYEBROWS TENDER TO FURROW EVEN MORE.

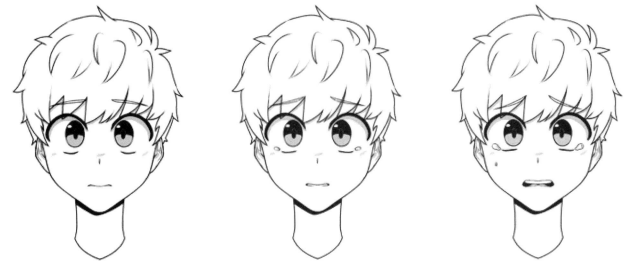

ITS NOT ONLY IMPORTANT TO READ THE STEPS, BUT TO TRY THEM OUT AS WELL! PLEASE USE THIS EMPTY SPACE TO PRACTICE THE STEPS YOU HAVE READ ON THE PREVIOUS PAGES.

ANGRY

AN ANGRY CHARACTER IS SOMETHING THAT WILL SHOW UP EVERY NOW AND THEN, ESPECIALLY IF THE CHARACTER IN QUESTION HAS AN ATTITUDE PROBLEM. THERE ARE CERTAIN CHARACTERISTICS THAT WOULD AFFECT HOW ANGRY SOMEONE WOULD LOOK, FROM BEING MILDLY ANNOYED TO FULL BLOWN FRUSTRATION. IN ORDER TO FIGURE OUT HOW TO CREATE THIS EXPRESSION, LET'S LOOK AT HOW TO BREAK THIS DOWN.

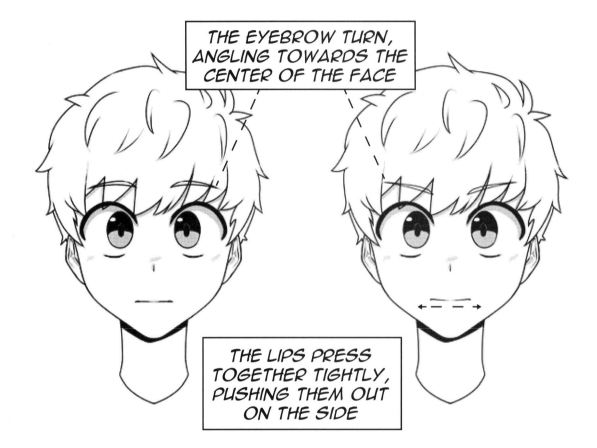

THE EYEBROW TURN, ANGLING TOWARDS THE CENTER OF THE FACE

THE LIPS PRESS TOGETHER TIGHTLY, PUSHING THEM OUT ON THE SIDE

THE ANGRIER PEOPLE ARE, THEY EXPRESS MORE, OPENING THE MOUTH WIDELY. THE FACE SCRUNCHES UP TOWARDS THE CENTER.

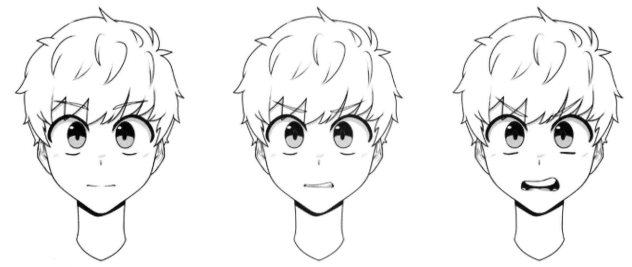

ITS NOT ONLY IMPORTANT TO READ THE NOTES, BUT TO TRY THEM OUT AS WELL! PLEASE USE THIS EMPTY SPACE TO PRACTICE THE THINGS YOU HAVE READ ON THE PREVIOUS PAGES.

CONFUSION

THE PUZZLED EXPRESSIONS WORN BY CHARACTERS WHO ARE CONFUSED IS ANOTHER FACE THAT IS NEEDED FOR STORY TELLING. THE LOOK WORN BY THESE CHARACTERS CAN BE USED FOR SCENES THAT ARE SILLY, AND ALL THE WAY TO MORE SERIOUS MOMENTS. THE KEY TO THIS EXPRESSIONS USAGE IS THE CONTEXT THEY ARE USED IN. LET US TAKE A LOOK AT THIS VARYING EXPRESSION, AND HOW TO DRAW IT EFFICIENTLY.

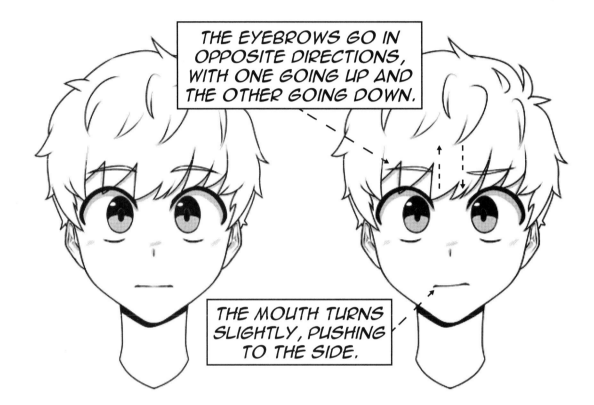

THE EYEBROWS GO IN OPPOSITE DIRECTIONS, WITH ONE GOING UP AND THE OTHER GOING DOWN.

THE MOUTH TURNS SLIGHTLY, PUSHING TO THE SIDE.

WITH CONFUSION, THE FACE WILL SCRUNCH AND TWIST MORE TO ONE SIDE, BECOMING LOPSIDED AND ASYMMETRICAL.

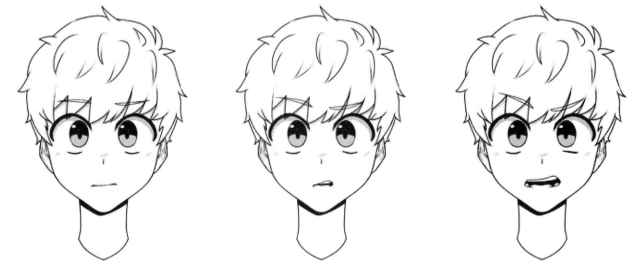

ITS NOT ONLY IMPORTANT TO READ THE STEPS, BUT TO TRY THEM OUT AS WELL! PLEASE USE THIS EMPTY SPACE TO PRACTICE THE STEPS YOU HAVE READ ON THE PREVIOUS PAGES.

SHOCK

THIS EXPRESSION IS KEY FOR SCENES IN ANIME AND MANGA THAT LET THE VIEWER KNOW THAT SOMETHING IS NEW AND SURPRISING. SHOCK CAN BE SEEN AS POSITIVE OR NEGATIVE, BUT THAT DEPENDS ON THE CONTEXT. WHEN A CHARACTER IS SURPRISED, THERE ARE CERTAINLY DIFFERENT VARYING DEGREES OF SHOCK, ANYWHERE FROM A SLIGHT SURPRISE TO ABSOLUTE SHOCK.

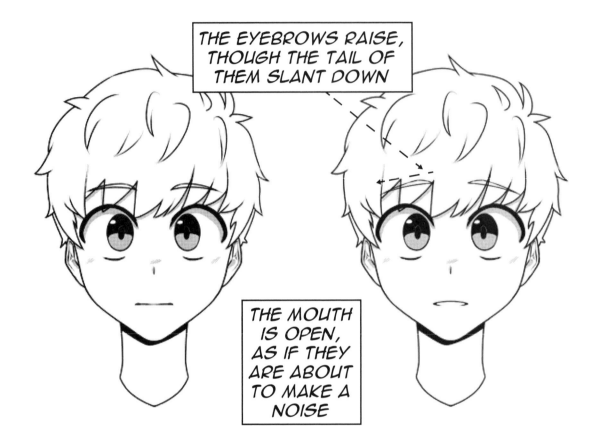

THE EYEBROWS RAISE, THOUGH THE TAIL OF THEM SLANT DOWN

THE MOUTH IS OPEN, AS IF THEY ARE ABOUT TO MAKE A NOISE

THE MORE SHOCK, THE MORE SOMEONE IS BOUND TO SAY SOMETHING OUTLOUD, LIKE "WHAT!" OR "HUH!?" THE MOUTH SHOULD REFLECT THAT.

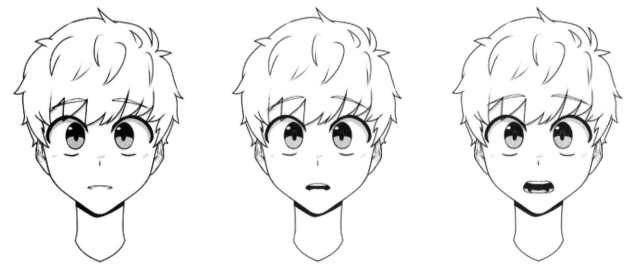

ITS NOT ONLY IMPORTANT TO READ THE NOTES, BUT TO TRY THEM OUT AS WELL! PLEASE USE THIS EMPTY SPACE TO PRACTICE THE THINGS YOU HAVE READ ON THE PREVIOUS PAGES.

CHIBI EXPRESSIONS

CHIBI FACES CAN HAVE SIMILAR EXPRESSIONS, THOUGH THEY ARE USUALLY FAR MORE SIMPLIFIED AND MORE CUTE LOOKING (EVEN WITH THE SERIOUS EXPRESSIONS) DUE TO THEIR PROPORTIONS.

WE WILL BE TAKING A LOOK AT HOW TO SIMPLIFY THESE EMOTIONS WE LEARNED BY COMPARING THEM TO THEIR REGULAR VERSIONS, AND TRANSLATE THEM TO FIT ON CHIBI PROPORTIONS.

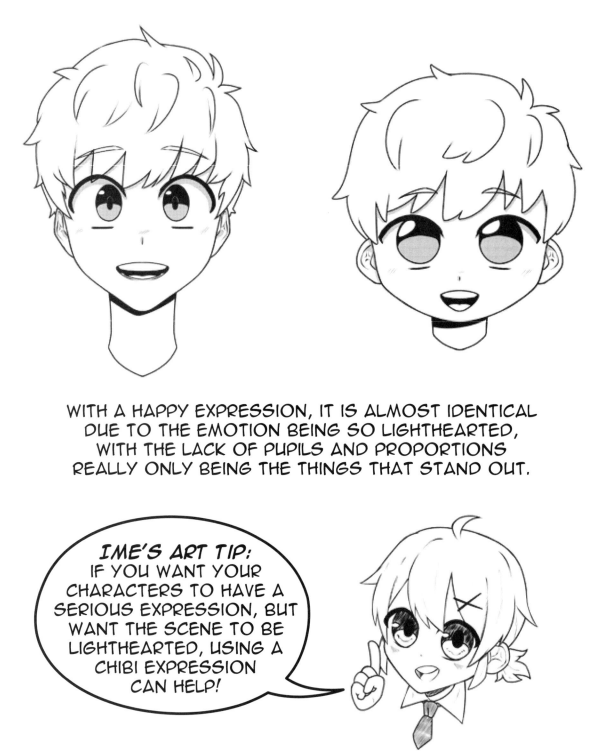

WITH A HAPPY EXPRESSION, IT IS ALMOST IDENTICAL DUE TO THE EMOTION BEING SO LIGHTHEARTED, WITH THE LACK OF PUPILS AND PROPORTIONS REALLY ONLY BEING THE THINGS THAT STAND OUT.

IME'S ART TIP:
IF YOU WANT YOUR CHARACTERS TO HAVE A SERIOUS EXPRESSION, BUT WANT THE SCENE TO BE LIGHTHEARTED, USING A CHIBI EXPRESSION CAN HELP!

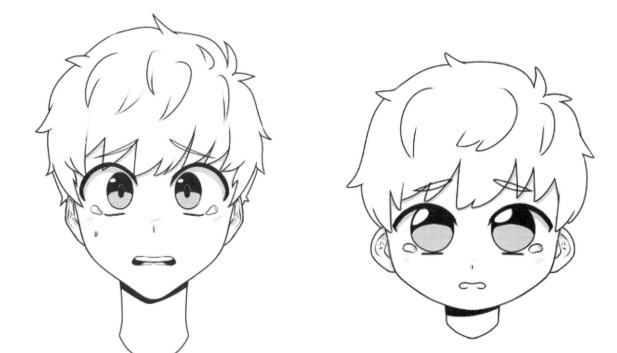

THE CHIBI EXPRESSION WILL END UP LOOKING CUTER AND NOT LOOK SO SERIOUS DESPITE A SAD EXPRESSION, SO PLEASE KEEP THIS IN MIND WHEN USING A CHIBI FACE.

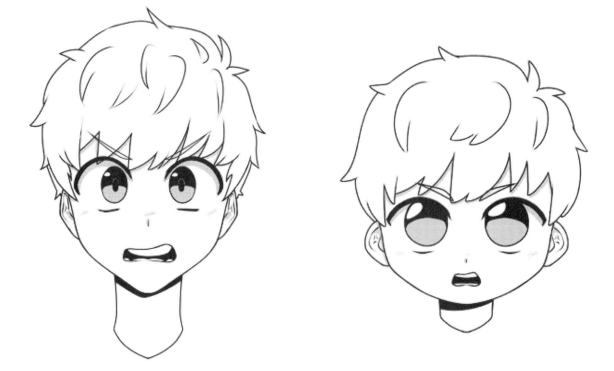

THE CHIBI EXPRESSION CAN PORTRAY THE ANGRY EXPRESSION PRETTY WELL, BUT ONCE AGAIN DUE TO THE CUTER PROPORTIONS, IT WOULD PROBABLY BE USED TO CREATE A LIGHTER-HEARTED SCENE.

14

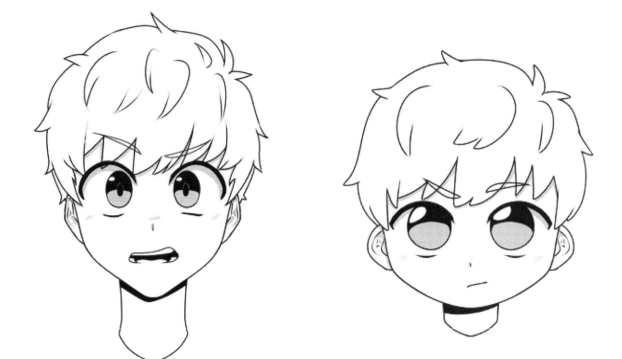

WITH CONFUSION, THE TINY FACE COMES OFF AS MORE CURIOUS, SOFTENING THE INTENSITY THAT CAN COME WITH THIS EXPRESSION.

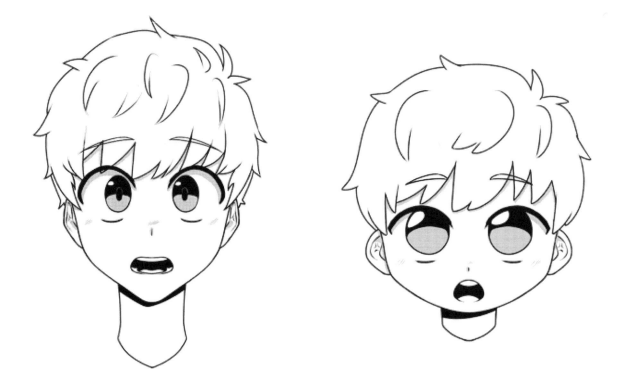

THIS VERSION OF THE SHOCKED EXPRESSION DOESN'T HAVE THE SAME EFFECT, PLEASE KEEP THIS MIND WITH CHIBI FACES. WE WILL DISCUSS THIS MORE ON THE NEXT PAGE.

THE USE OF CHIBIS IN A REGULAR SCENE CAN BE USED TO MAKE A MOMENT LESS SERIOUS, OR FOR COMEDIC PURPOSES. TAKE THESE PANELS FOR EXAMPLE: A REGULAR FACE WOULD MAKE THIS SCENE LOOK AWKWARD, WITH THE WAVE OF EMOTIONS BEING SADNESS AND SHOCK OVER A MELTED POPSICLE. THE FEATURES ON THE CHIBI FACE HELP SHOW THE EXAGGERATION OF THEIR PREDICAMENT IN A FUNNIER WAY SINCE IT ISN'T REALLY THAT SERIOUS, BUT WE CAN ALL RELATE BEING SAD WHEN WE DROPPED A TREAT WE WERE LOOKING FORWARD TO EATING.

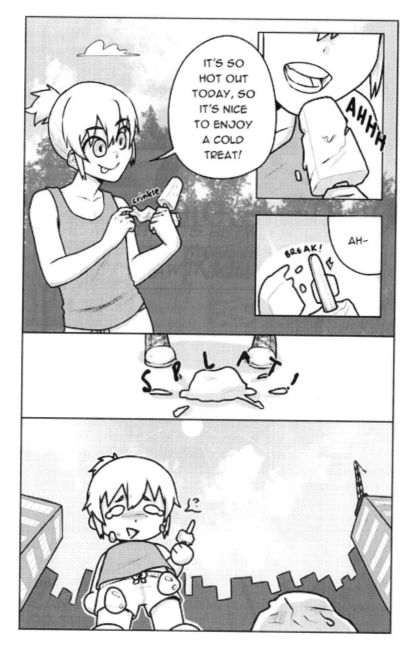

SOMETIMES A CHIBI EXPRESSION DOESN'T HOLD THE LEVEL OF EMOTION NEEDED DUE TO THEIR CUTE NATURE, WHICH IS WHY WE TURN TO A DIFFERENT SORT OF EXPRESSION WITH CHIBI FACES, LIKE THE ONE IN THE LAST PANEL. MANGAKA USE DIFFERENT EXPRESSIONS IN FUNNIER SCENES, BUT IT ALMOST ALWAYS INVOLVES SIMPLIFYING THE CHARACTER IN SOME FORM (MOST SEEN IN THE FACE). UNDERSTANDING THIS CAN HELP YOU DRAW MORE EFFECTIVE MANGA PANELS.

ITS NOT ONLY IMPORTANT TO READ THE STEPS, BUT TO TRY THEM OUT AS WELL! PLEASE USE THIS EMPTY SPACE TO PRACTICE THE STEPS YOU HAVE READ ON THE PREVIOUS PAGES.

CONCLUSION

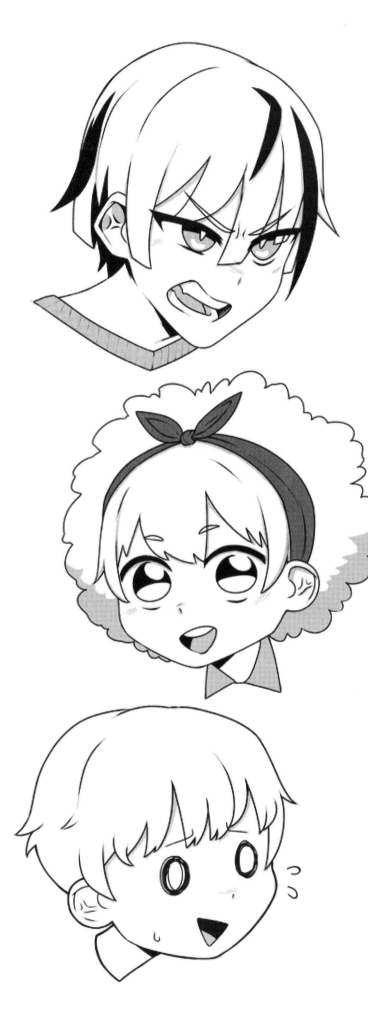

EXPRESSIONS ARE IMPORTANT FOR STORYTELLING AND LETTING THE VIEWER GET A BETTER UNDERSTANDING OF A CHARACTER ON THE PAGE. LETTING YOUR CHARACTERS EMOTE IS KEY TO DRAWING EFFECTIVE ANIME AND MANGA DRAWINGS.

WHEN THE CHARACTERS EXPRESS THEIR FEELINGS, IT IS A WINDOW TO THEIR MIND AND HEART. IT ALLOWS THE VIEWER TO SEE HOW EVERYONE IS FEELING, FROM CASUAL TO MORE SERIOUS SCENES. LIGHTHEARTED MOMENTS TO HIGH-TENSION ACTION SCENES, THE WAY A CHARACTER SITS IN THOSE IS VERY TELLING OF WHO THEY ARE AND HOW THEY ACT.

IT IS IMPORTANT TO PRACTICE A WIDE VARIETY OF EXPRESSIONS, AND TO STUDY HOW TO USE THEM PROPERLY AND EFFECTIVELY. THIS IS ONE PART THAT IS CERTAINLY BENEFITTED BY STUDYING OTHER PEOPLE'S EXPRESSIONS. TRY LOOKING AT SOME CHARACTERS YOU LIKE, AND LOOK AT THEIR EXPRESSIONS IN DIFFERENT SCENES AND MOMENTS.

THIS WILL HELP YOU FURTHER IMPROVE YOUR SKILLS WITH DRAWING MANGA AND ANIME CHARACTERS!

FREE Lessons, Book Giveaways and Much More!

Website: josephstevenson.com

YouTube: youtube.com/c/josephalanstevensonblog

Facebook: facebook.com/josephalanstevenson

Instagram: instagram.com/josephalanstevenson

Pinterest: pinterest.com/josephalanstevenson

SECTION 4: HAIR

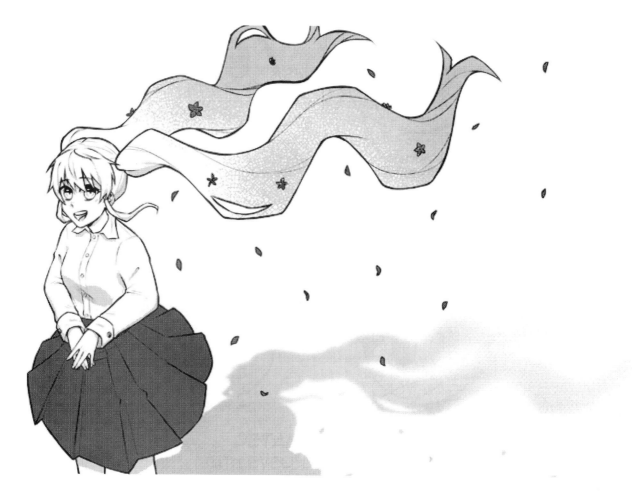

INTRODUCTION

HAIR IS AN ULTIMATE PART OF CHARACTER DESIGNS IN ANIME AND MANGA THAT ARE CRITICAL TO HELPING MAKE A CHARACTER LOOK UNIQUE. THINK OF SOME POPULAR CHARACTERS IN MANGA AND ANIME, AND THINK ABOUT THEIR DESIGNS, PRIMARILY THEIR HAIRSTYLES.

WHILE THERE ARE SOME COMMON STYLES, THERE ARE ALSO ONES THAT COMPLETELY STAND OUT! HOW CHARACTERS LOOK CAN BE COMPLETELY ALTERED AND EFFECTED BY THE WAY THEIR HAIR IS DRAWN! THAT'S WHY YOU WILL NOTICE ALOT OF CHARACTERS, WHEN LEVELING OR POWERING UP, THEIR HAIR IS ONE OF THE FIRST THINGS TO CHANGE.

THERE IS AN UNLIMITED CHOICE OF COMBINATIONS AND STYLES YOU CAN USE. BECAUSE OF THIS HUGE VARIETY, IT CAN BE INTIMIDATING TO THINK OF WHERE TO START.

IN THIS SECTION, WE WILL BE GOING OVER SOME DIFFERENT METHODS OF HOW TO BUILD HAIR AND CREATE HAIRSTYLES SO YOU CAN MAKE LOOKS OF YOUR VERY OWN! WE WILL EVEN SHOW EXAMPLES SO YOU CAN START ON YOUR JOURNEY OF DRAWING EXCITING AND UNIQUE HAIR!

HOW TO CREATE HAIR

THERE ARE UNSPOKEN RULES TO DRAWING HAIR THAT CAN HAVE EITHER A NEGATIVE OR POSITIVE IMPACT ON YOUR DESIGNS. IF DONE INCORRECTLY IN AN UNINTENTIONAL WAY, IT CAN MAKE A DRAWING LOOK ODD. SO BEFORE WE ACTUALLY DRAW HAIR, WE SHOULD GET A BETTER UNDERSTANDING OF HOW TO CREATE HAIR.

WHAT DOES THIS MEAN?

IT MEANS THAT WE NEED TO LEARN ABOUT THESE RULES, AND DEMONSTRATE HOW TO DRAW HAIR EFFECTIVELY AND STYLISTICALLY. WE WILL DISCUSS THESE IN DEPTH SO YOU CAN HAVE A SOLID FOUNDATION ON MAKING HAIR.

WHEN CREATING HAIR, WE NEED TO FIRST LOOK AT WHICH STYLE OF HAIR WE ARE DOING. JUST LIKE IN REAL LIFE, PEOPLE HAVE ALL DIFFERENT KINDS OF HAIR TEXTURES.

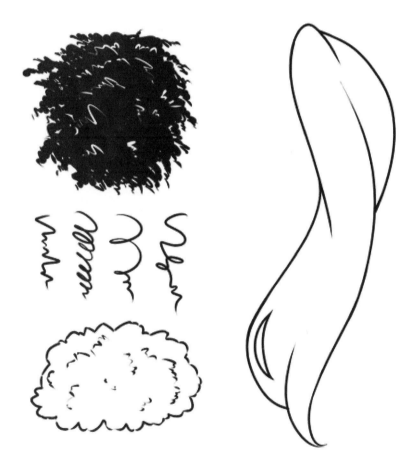

IF WE LOOK AT THIS CHART, THIS IS JUST A SMALL SAMPLE OF THE VARIETY OF TEXTURES PEOPLE CAN HAVE IN THEIR HAIR. BEFORE YOU DRAW HAIR, UNDERSTANDING WHAT TEXTURE YOUR CHARACTER WILL HAVE CAN AFFECT HOW IT WILL BE DRAWN.

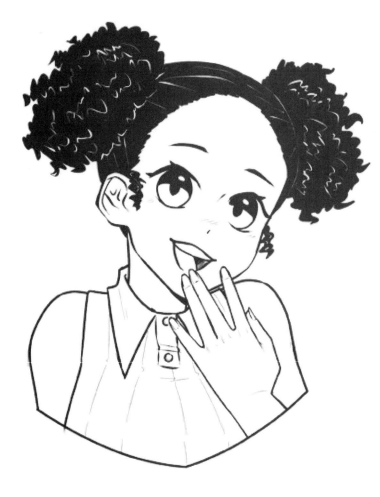

TEXTURED HAIR

THE MORE TEXTURE THAT HAIR HAS, THE MORE IT WILL COIL AND BUNCH UP TOGETHER.

THESE SHAPES AND FORMS CAN BE SIMPLIFIED, BY EITHER USING A THICKER LINE OR CREATING A GENERIC SHAPE BASED ON THE TEXTURE OF HAIR.

IN THIS DRAWING WE USE A SOURCE OF THICK AND WAVY LINES TO CREATE MULTIPLE CURLS. BELOW IS A STEP-BY-STEP GUIDE ON HOW TO CREATE TEXTURED HAIR.

REMEMBER, THE TIGHTER THE CURLS, THE CLOSER THE LINES WILL BE!

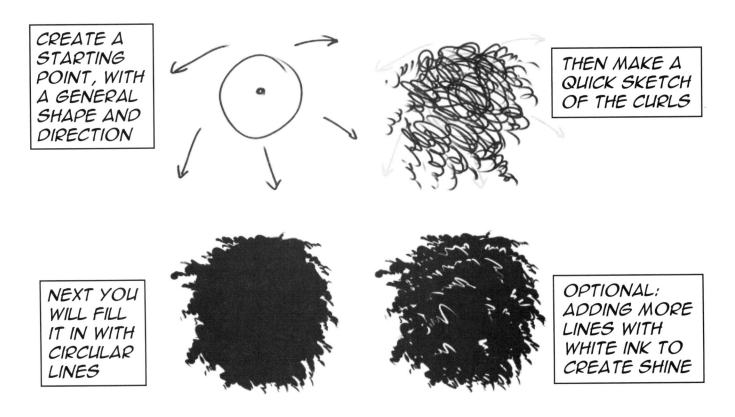

CREATE A STARTING POINT, WITH A GENERAL SHAPE AND DIRECTION

THEN MAKE A QUICK SKETCH OF THE CURLS

NEXT YOU WILL FILL IT IN WITH CIRCULAR LINES

OPTIONAL: ADDING MORE LINES WITH WHITE INK TO CREATE SHINE

4

ITS NOT ONLY IMPORTANT TO READ THE STEPS, BUT TO TRY THEM OUT AS WELL! PLEASE USE THIS EMPTY SPACE TO PRACTICE THE STEPS YOU HAVE READ ON THE PREVIOUS PAGES.

SMOOTH HAIR

THE KEY TO DRAWING THIS STYLE OF HAIR IS TO UNDERSTAND THAT WE START WITH ONE SECTION, AND BREAK OFF FROM THERE.

THIS STYLE OF HAIR FOLLOWS THE SAME RULES, NO MATTER THE LENGTH OR STYLE. THE HAIR BREAKS OFF AND SPLITS INTO SMALLER PARTS. BELOW IS A STEP-BY-STEP GUIDE EXPLAINING THIS IN BETTER DETAIL.

WHEN YOU ARE WORKING WITH MORE SMOOTH HAIR, THE LINE ART SHOULD REPRESENT THAT AS WELL.

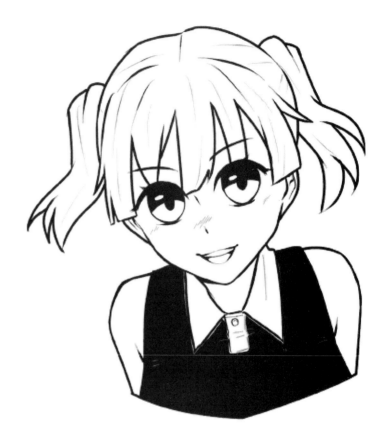

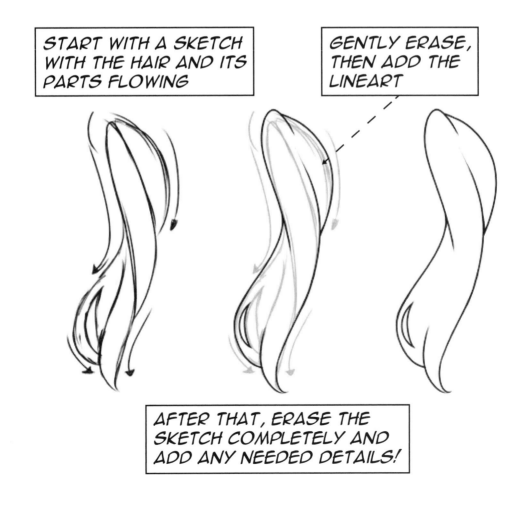

START WITH A SKETCH WITH THE HAIR AND ITS PARTS FLOWING

GENTLY ERASE, THEN ADD THE LINEART

AFTER THAT, ERASE THE SKETCH COMPLETELY AND ADD ANY NEEDED DETAILS!

ITS NOT ONLY IMPORTANT TO READ THE STEPS, BUT TO TRY THEM OUT AS WELL! PLEASE USE THIS EMPTY SPACE TO PRACTICE THE STEPS YOU HAVE READ ON THE PREVIOUS PAGES.

HOW TO BUILD HAIRSTYLES

NOW THAT YOU HAVE A BETTER UNDERSTANDING OF HOW TO CREATE HAIR, WE CAN NOW USE THIS KNOWLEDGE TO CREATE HAIRSTYLES FROM SCRATCH! THIS CAN SEEM DAUNTING, BUT IF WE BREAK IT DOWN INTO SECTIONS, IT CAN BE EASIER TO UNDERSTAND.

THE HAIR WILL HAVE A STARTING POINT OF SOME SORT, WHETHER IT IS FROM THE BANGS AREA OR FROM A PONY TAIL (THOUGHT WE WILL DISCUSS THIS IN MORE DETAIL LATER ON.) ONCE WE HAVE THESE POINTS NOTED, WE WILL CREATE THE SECTIONS OF HAIR BASED ON THE RULES WE LEARNED.

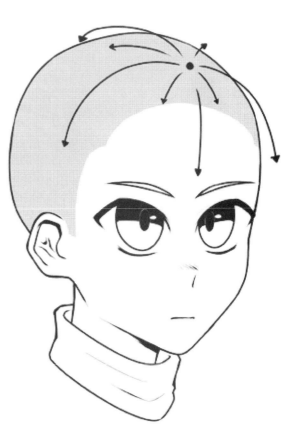

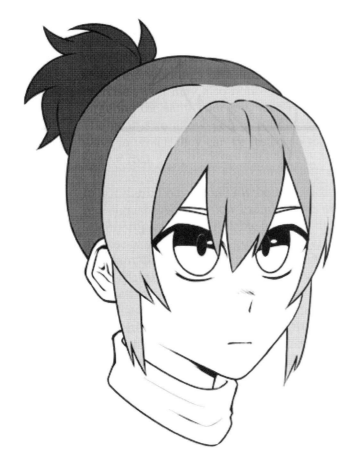

ONCE WE UNDERSTAND WHERE OUR "STARTING POINT" WILL BE, WE CAN CREATE THE SECTIONS OF HAIR. EACH SECTION IS LABELED ACCORDINGLY.

8

THIS BASE FOR HAIR CAN HELP WHEN DRAWING YOUR CHARACTERS FROM DIFFERENT ANGLES, AND CAN HELP WITH CONSISTENCY. IT CAN ALSO HELP IF YOU AREN'T QUITE SURE WHERE THE SECTIONS WOULD GO. LET'S TAKE A LOOK AT HOW THESE SECTIONS LOOK FROM DIFFERENT ANGLES.

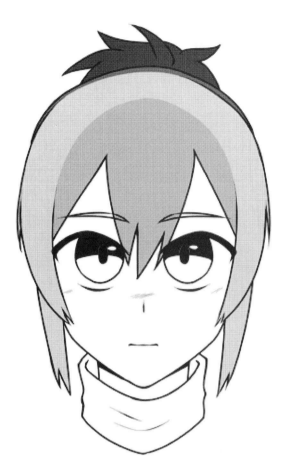

SOME PARTS, LIKE THE BASE SECTION, WILL NOT BE AS VISIBLE FROM A FRONT-FACING POSITION. IT IS STILL IMPORTANT TO KEEP NOTE OF IT, SO YOU CAN STILL WORK FROM A POINT OF REFERENCE.

KEEP IN MIND THE PROPORTIONS WITH EACH ANGLE. IF THE SIDE BANGS GO DOWN TO THE CHIN, KEEP THAT SAME LENGTH WITH EACH ANGLE! CONSISTENCY WILL HELP WITH BOTH DESIGN AND AVOID ANY CONFUSION DOWN THE ROAD.

ONCE WE UNDERSTAND HOW THE SECTIONS OF HAIR WORK, WE CAN CREATE DIFFERENT COMBINATIONS AND STYLES OF HAIR. IN THE NEXT COUPLE OF PAGES, WE WILL TAKE A LOOK AT HOW THESE RULES WILL APPLIED BASED ON DIFFERENT LENGTHS OF HAIR.

LET'S PRACTICE!

BELOW IS A SET OF BLANK HEADS (WITH A HAIRLINE ALREADY SET IN PLACE. TRY CREATING YOUR OWN STARTING POINTS, AND MAKE SOME HAIRSTYLES WHILE REMEMBERING HOW THE SECTIONS OF HAIR WORK!

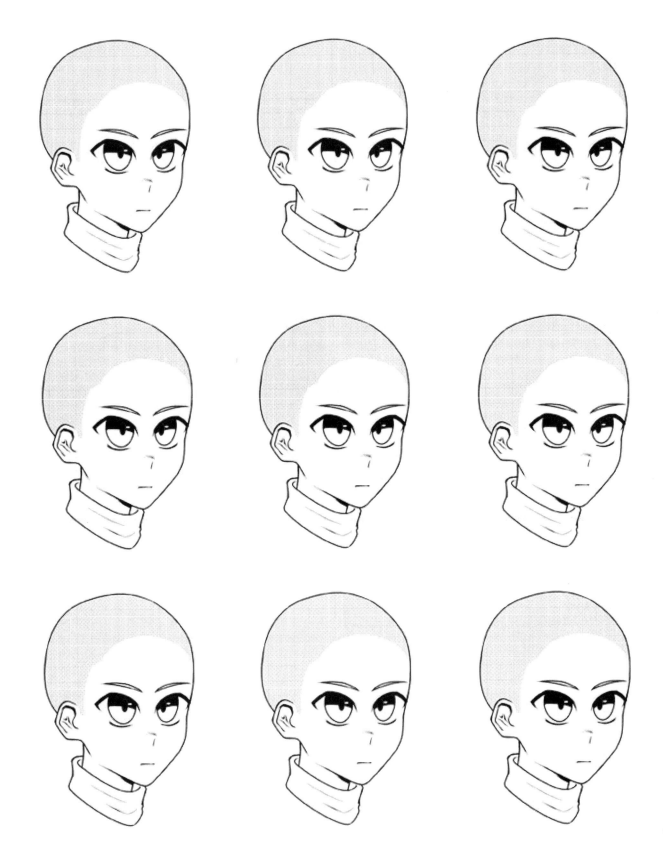

SHORT HAIR

SHORT HAIR STYLES TEND TO BE LIGHTER AND STICK "UP" MORE, DUE TO SHORT HAIR WEIGHING LESS THAN LONG HAIR (THIS IS A GENERAL OBSERVATION, AND NOT A CONSISTENT RULE). THE HAIR CAN ALSO TEND TO GO IN DIFFERENT DIRECTIONS DUE TO THE FACT THAT THEY ARE NOT WEIGHED DOWN BY GRAVITY. THESE STYLES CAN COME OUT FROM DIFFERENT POINTS, THE DIRECTION OF THE HAIR TENDING TO POINT AWAY FROM THE STARTING PART.

STYLED HAIR MIGHT FLOW DIFFERENTLY, SINCE IT IS USUALLY COMBED DOWN AND SMOOTHED WITH GEL. LOOKING AT AND STUDYING HAIRSTYLISTS' WORK ON SHORTER HAIR CAN HELP YOU GAIN A BETTER UNDERSTANDING OF THIS.

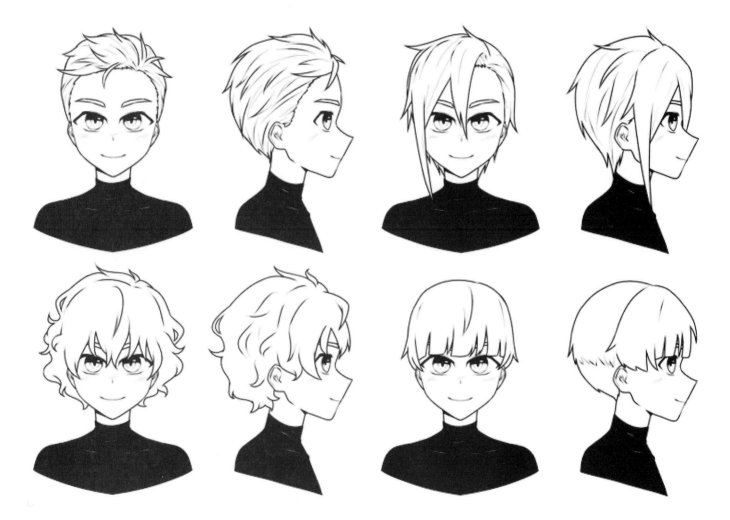

THERE IS OBVIOUSLY A MULTITUDE OF STYLES YOU COULD DO, BUT FOR THIS BOOK WE WILL GIVE A FEW EXAMPLES TO START OFF WITH.

JUST LIKE REAL LIFE, PEOPLE CAN WEAR THEIR HAIR IN DIFFERENT WAYS, BUT AS LONG AS YOU FOLLOW THE BASIC RULES YOU WILL DO GOOD!

ITS NOT ONLY IMPORTANT TO READ THE STEPS, BUT TO TRY THEM OUT AS WELL! PLEASE USE THIS EMPTY SPACE TO PRACTICE THE STEPS YOU HAVE READ ON THE PREVIOUS PAGES.

LONG HAIR

LONG HAIR CAN HAVE A HUGE VARIETY OF VISUAL POSSIBILITIES DUE TO THE COMBINATION OF LENGTHS AND STYLES THEY CAN HAVE. WHEN HAIR IS PUT INTO A PONYTAIL OR ANY SORT OF FASTEN, THE HAIR WILL BE BUNCHED TOGETHER THEN EXPAND FROM THAT NEW POINT. BUT REMEMBER THE SAME RULES WILL APPLY TO THIS SECTION OF HAIR!

TO CREATE MORE REALISTIC HAIR STYLES, KEEP IN MIND THAT SMOOTHER HAIR DOES NOT DEFY GRAVITY AS MUCH AS CURLIER HAIR DOES (BUT EVEN TEXTURED HAIR HAS ITS LIMITS AND WILL INEVITABLY BE WEIGHED DOWN).

LET'S TAKE A LOOK AT SOME EXAMPLES OF LONG HAIR!

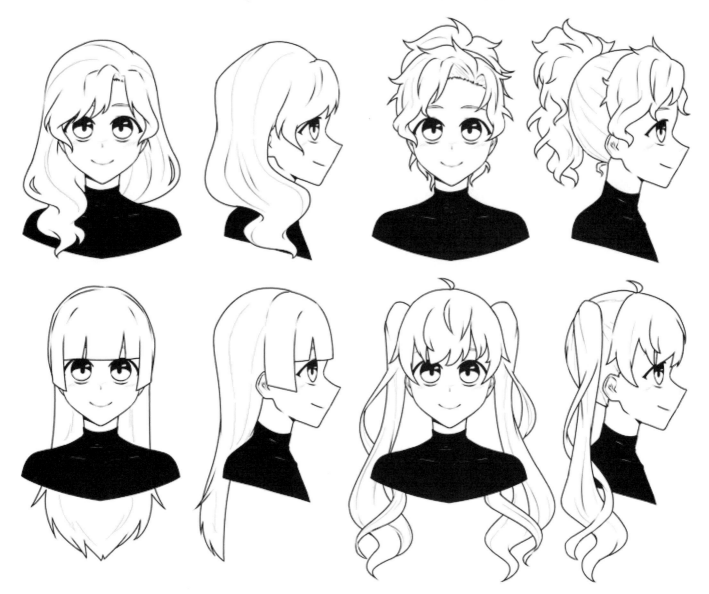

WITH LONGER HAIRS, WE WILL USUALLY SEE MORE STYLES APPLIED TO THEM, SUCH AS PONYTAILS OR BRAIDS. IT IS UP TO YOU WHETHER AS THE ARTIST TO DRAW THAT OR NOT.

13

ITS NOT ONLY IMPORTANT TO READ THE STEPS, BUT TO TRY THEM OUT AS WELL! PLEASE USE THIS EMPTY SPACE TO PRACTICE THE STEPS YOU HAVE READ ON THE PREVIOUS PAGES.

CONCLUSION

HAIRSTYLES HAVE A PLETHORA OF THE DIFFERENT COMBINATIONS AND POSSIBILITIES, LEADING TO MULTIPLE KINDS OF DESIGNS YOU CAN USE FOR YOUR CHARACTERS! MIXING AND MATCHING HAIR CAN HELP TO CREATE UNIQUE AND NEW STYLES!

WITH DIFFERENT HAIRSTYLES, YOU CAN HELP PORTRAY YOUR DIFFERENT CHARACTERS, AND ALLOW YOU TO MAKE DIVERSE CHARACTERS FOR YOUR DRAWINGS AND STORIES. MAKING YOUR CHARACTERS LOOK DIFFERENT CAN HELP ANY CONFUSION, AND LET EACH ONE SHINE IN THEIR OWN WAY.

ENVIROMENTS CAN ALSO PLAY A KEY IN THESE CHOICES (LIKE IF YOUR CHARACTER IS A STUDENT OR SUPER HERO) AND CAN HELP PUSH YOUR NARRATIVE FURTHER.

REMEMBER TO STUDY HAIRSTYLES IN REAL LIFE TO HELP IMPROVE YOUR SKILLS! LOOKING AT THE VARIETIES OF STYLES IN REAL LIFE CAN HELP BOOST YOUR CREATIVITY AND MAKE CHARACTER CREATION A LOT EASIER!

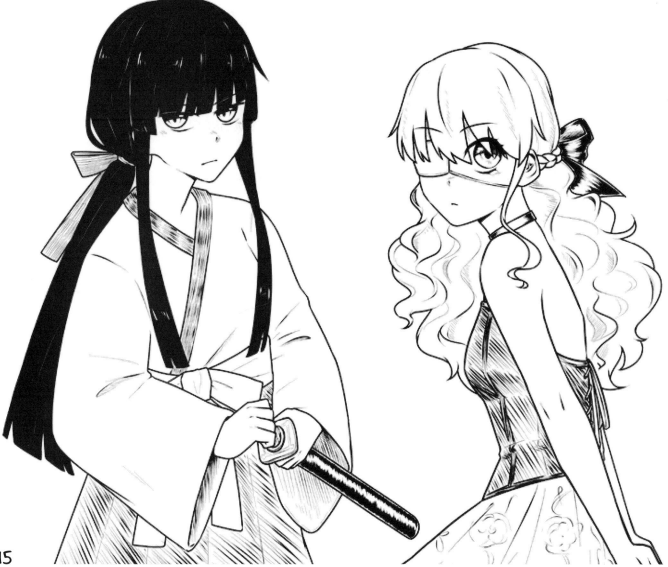

Want to Connect?
Joseph is on major social media sites like Facebook, Instagram and a whole bunch more! Connect with him by visiting josephstevenson.com and visiting his profiles.

FREE Lessons, Book Giveaways and Much More!

Website: josephstevenson.com

YouTube: youtube.com/c/josephalanstevensonblog

Facebook: facebook.com/josephalanstevenson

Instagram: instagram.com/josephalanstevenson

Pinterest: pinterest.com/josephalanstevenson